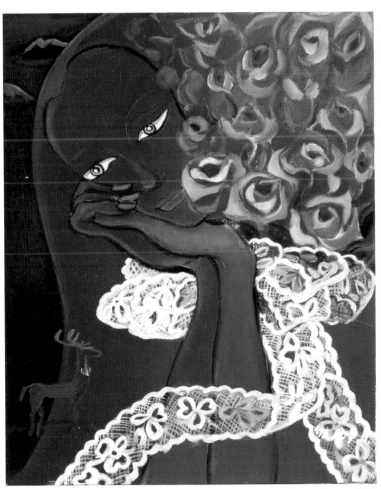

백아의 집시 The Midnight Sun's Gypsy 53×45.5cm, Oil on Canvas, 2000

자화상 63.5×81.5cm, Oil on Canvas

Art
Cusmos

심 선 희

Shim Sun Hee

서문당

심 선 희
Shim Sun Hee

초판인쇄 / 2017년 3월 31일
초판발행 / 2017년 4월 10일

지은이 / 심선희
펴낸이 / 최석로
펴낸곳 / 서문당
주소 / 경기도 일산서구 가좌동 630
전화 / (031) 923-8258
팩스 / (031) 923-8259
창업일자 / 1968.12.24
창업등록 / 1968.12.26 No.가2367
등록번호 / 제406-313-2001-000005호

ISBN 978-89-7243-677-5

차례
Contents

한국청년작가연립전(1967년)

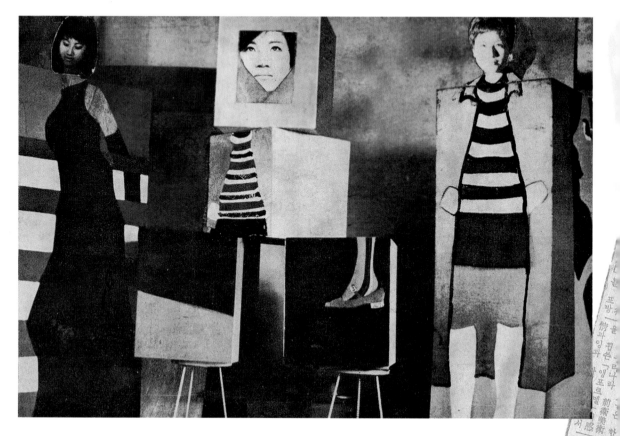

1967년 12.11~12.16 중앙공보관에서 한국청년작가연립전 오리진 무동인 신전동인 세 그룹의 전시로 실험미술과 헤프닝이 이루어진 전시회에 신전동인의 멤버로 심선희는 탈 평면 최초의 오브제 합판이나 나무상자를 만들어 가죽과 사진 신소재 스폰지 스티로폴 등을 오리고 붙친 입체작품 미니 1, 미니2를 선보였고 오광수 극본의 최초의 헤프닝도 참가하였다.

1967년 12월 23일자
동아일보 지면

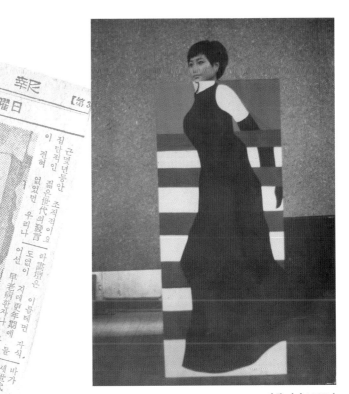

작품 미니 1967년

<沈善喜作『미니』>

生活하는 젊은 美術

「韓國青年作家聯立展」을 보고

李逸

이 집단적인 군것붓년동안 조직적이고 전혀 없었던 우리나 어선 도입이 지레 早老病환자나 다들 세世代와 단절된 채 나에 權威와도 기력이 무는가 우리 藝壇에만 과하거나 집착하면서 그리고 그것은 旣成의 애써 敗北主義의 生理, 이고 아니면 그것은 귀를막으려는 挑戰했다 그진정한 價値 당연히 美術 그자체에 대해 깔린 이聯立展은 요소가 그명칭 하리의 그리고 面性의 교수의 平面性과 裝飾性이 고 그 誤謬 그리고 蠶落品의 고립된 갤러리스러는 그 눈에 보이는 물체 내는듯이 제보는가 라는 젊은이들의 「反—藝術」의 과격하고 생활의 再形像의 배인가 日常的인 오브제를 생활의 元素의 驚異한 사크시켜주는 藝術— 버리는 듯이 反抗하기에 普遍的인 생활의 再現이지만 리게 달리하는 「生活하는 만든다 그러고는 변에 독같은 「生活」하는 배인기 「無同人」들은 지향하고 진이 「新同人」들은 지향하 새로운 선율을

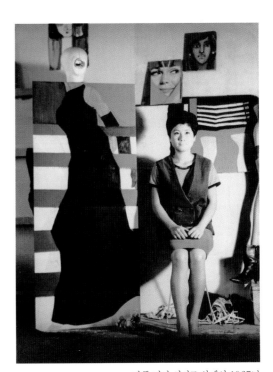

작품 미니 시리즈 앞에서 1967년

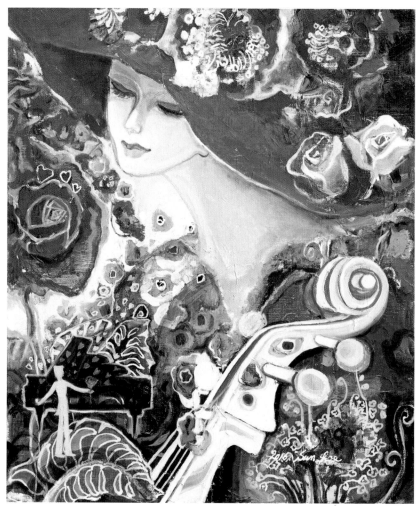

뮤직드림 *Music Dream* 53×45.5cm, Oil on Canvas, 2016

콘트라베이스 작품 옆에서

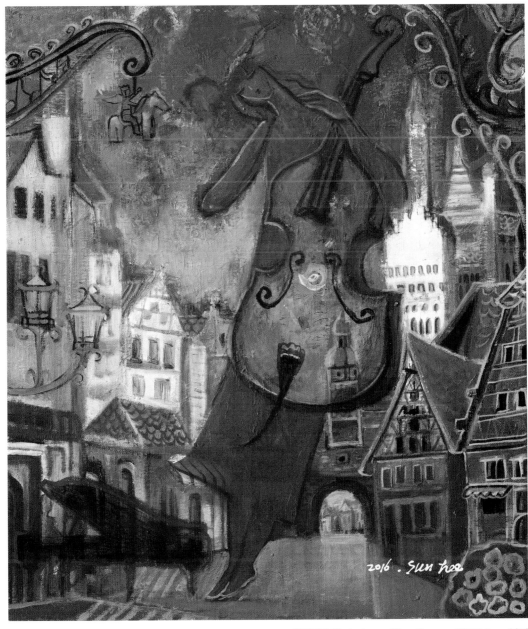

뮤직드림 *Music dream* Oil on Canves, 53×45.5cm, 2016

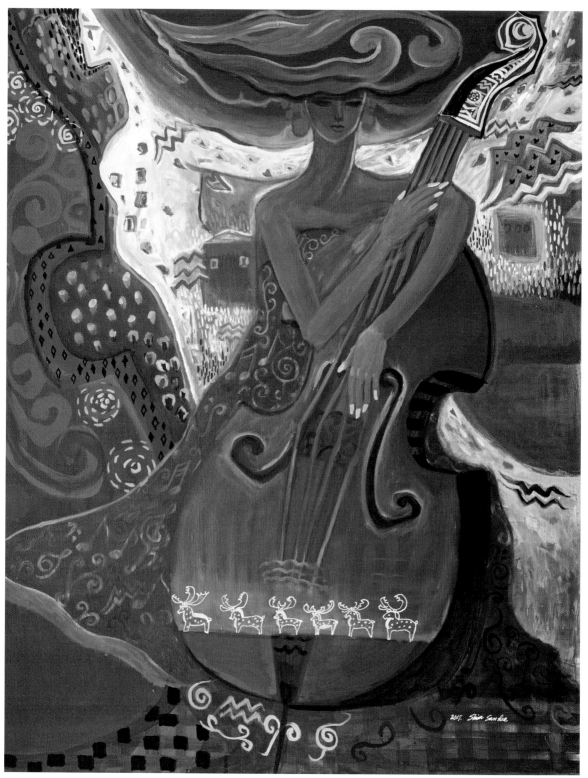

뮤직드림 *Music Dream* 145.5×112.1cm, Oil on Canvas, 2017

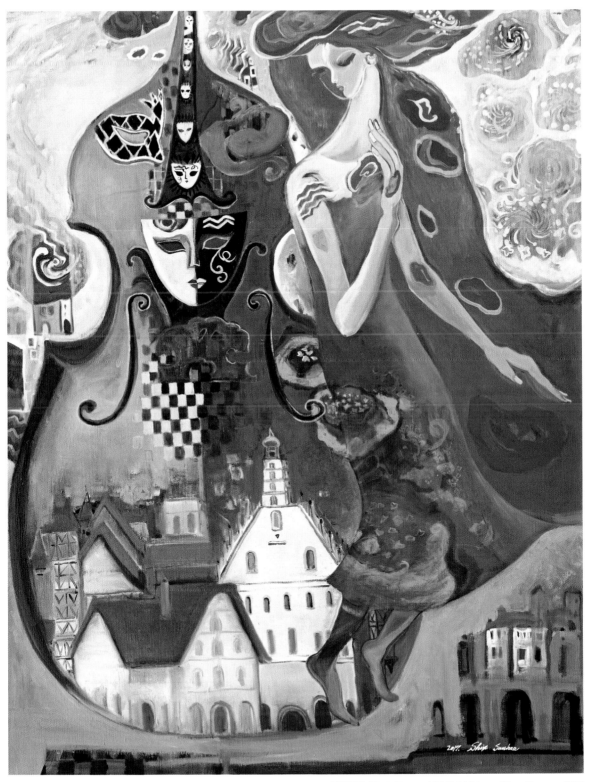

뮤직드림 *Music Dream* 145.5×112.1cm, Oil on Canvas, 2017

우리 시대 집시의 자화상
― 심선희 근작전

김복영 / 미술평론가 · 전 홍익대 교수

1

회화에서 집시gypsy라 하면 의당 앙리 루소(Henri Rousseau 1844~1910)의 〈잠자는 집시〉를 떠올린다. 그림의 무대는 시간으로 해가 서산에 지고 땅거미가 짙게 드린 산등성이의 저녁이다. 삶에 지친 집시 여인이 만도린을 옆에 놓고 깊은 잠에 들었는데, 먹이를 찾는 큰 몸집의 사자가 집시의 몸 냄새를 맡고 다가와 응시하는 장면을 다루었다. 그의 〈꿈〉 또한 이와 유사한 장면을 그렸다. 집시 대신 왜소한 나신의 여인이 숲을 소파로 해서 누웠는데 숲 아래선 음산한 뱀이 몸체를 이동하고 어디선가 갈대 피리소리가 홀연히 들려오는 원시 목가牧歌풍의 그림이다.

루소는 그의 이름이 뜻하는 것처럼, 다갈색의 머리칼에 도미나 잉어과의 물고기처럼 정처 없이 유영하고 배회하는 보헤미안의 천성을 타고났다. 전직 세관원을 퇴직하자 이내 몰입한 게 그림이었다. 그림이야 말로 그가 삶의 자유를 지탱해주는 최선의 안식처였다. 배운 적도 없는 그림임에도 천성만으로 오직 자유를 만끽하기 위한 수단으로 그림을 선택했다. 그가 제작한 그림은 즉시 미술계의 반향을 불러일으켰다. 이를 알아본 건 당시 살롱을 풍미했던 앵그르계의 작가들이 아니라, 가난한 노부부와 광대를 그리던 '청색시대' 피카소의 주변 작가들이었다. 이들이야 말로 경직된 당시 살롱풍을 뒤로하고 고갱이 그처럼 먼 곳(타이티) 까지 찾아가야 했던 청정 감성파들이었다. 그들은 루소의 그림에 즉각 전율과 감동의 박수를 보냈다.

뮤직드림
Music Dream
25.8×17.9cm, Oil on Canvas, 2016

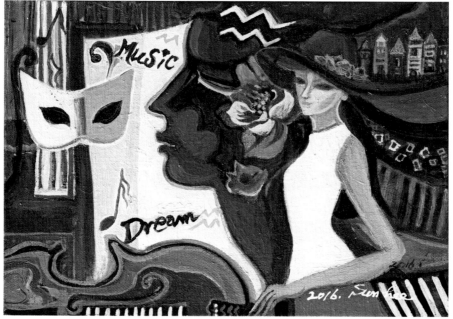

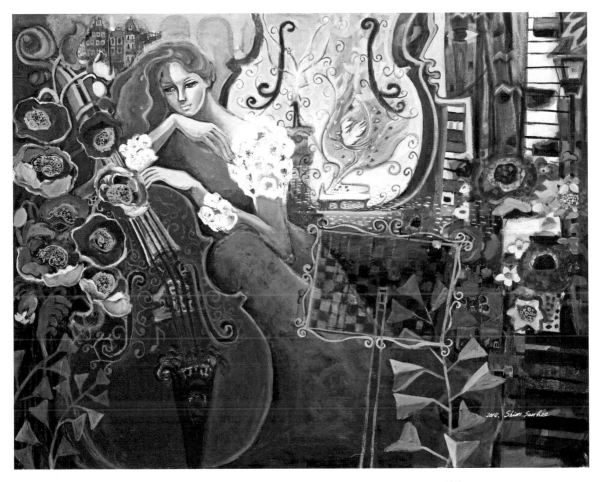

집시
Gypsy
116.8×91cm, Oil on Canvse, 2014

2

　화가 심선희의 근작전에 즈음해서 루소를 먼저 말하는 건 이 두 사람이 교묘하게 감성적 쌍을 이룬다는 데 있다. 그녀는 루소가 그랬던 것처럼, 상상의 집시가 되어 세계를 누비면서 여러 곳의 풍물을 청징한 감성으로 그렸고 그림 그리는 동기나 방식에 있어서 동류의 삶을 갖고 있다.

　그녀가 그리는 그림은 그러나 루소와 달리 미대를 나온 전업화가가 할 수 있는, 가난한 집시가 아니라 화려한 집시의 그림이다. 꾸밈없는 보헤미아니즘의 시선으로 일격을 가하듯이 풍요의 극치를 달리는 우리 시대의 세상사를 그려낸다. 그녀의 그림은 물질문명의 극을 달리는 21세기 시대상의 단면을 보여준다. 루소가 그랬듯이, 그녀 또한 유년 시절부터 환상 속에서 자유를 갈망하며 성년이 되어 정처 없이 세계를 유랑하면서, 자신의 꿈꾸는 집시 여행에서 조우했던 사람들의 고독과 풍요한 삶의 이면을 묘사한다. '언젠가 스케치 여행으로 어머니와 둘이서 러시아의 모스크바를 들렀는데 거기서 만난 순수한 집시 가족들에게서 동질감을 느꼈다'(「노트」 2015)고 말하는 데서 타고난 집시 기질이 묻어난다.

근작들은 크게 3가지 부류의 주제를 다룬다. 하나는 백야의 나라 모스크바와 생페터르스부르크 에르미따쥬 미술관을 경유하는 과정에서 만난 것들을 소재로 한 것이고, 다른 하나는 핀란드 헬싱키를 향한 기차 시벨리우스호를 타고 가다 본 자작나무 숲과 호수를 지나 노르웨이 피요르드에 이르는 보랏빛 환상과 동화의 나라 덴마크의 인어공주를 만나기까지의 체험적 주제를 다룬다. 여기에다 북유럽·서유럽·캐나다·미주·동남아·남태평양이 자신에게 각인시킨 소재들을 크로스오버한다. 마지막은 작가가 그토록 좋아하는 도시의 음악여행을 다룬 주제들이다. 이것들은 노트르담 드 파리의 샹송, 뮤지컬 오페라의 유령, 지킬 앤 하이드, 명성황후, 수위니 토드 등 팝페라와 혼성테너 음악콘서트에서 얻은 영감을 회화적으로 번안한, 이를테면 음악과 회화를 교감시킨 작품들이다.

<div align="center">3</div>

작가가 자신의 집시 여행에서 얻은 소재를 다룬 작품들은 주로 화려한 무대에서 볼 수 있는 프리마돈나를 주인공으로 등장시킨다. 첼리스트, 하얀 피아노와 흰옷의 피아니스트와 흰의상의 성악가, 검은 피아노와 검은 의상의 피아니스트와 검은 의상의 성악가를 동급의 주인공으로 등장시키는 것은 물론이다. 여기

콘서트의 여인
A Woman at a concert
53×45.5cm, Oil on Canvas, 2016

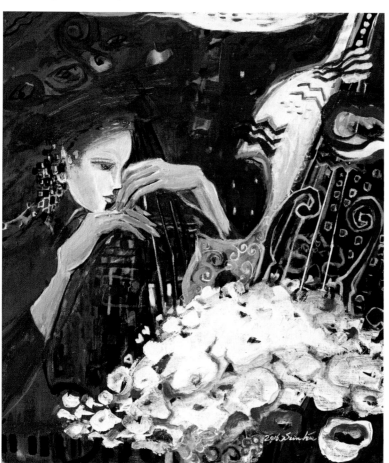

에다 배경으로는 꽃마차, 꽃사슴, 에펠탑, 화려한 돔의 페르시아풍 궁전, 이름 모를 꽃과 고기, 고급와인 테이블, 꽃무늬 의상, 화려한 침실과 카펫 같은 환상 세계에서나 볼 수 있는 비경을 다룬다. 청색조와 적색조의 순도 높은 화려가 눈길을 끈다. 프리마돈나와 첼리스트. 피아니스트의 주인공들이 꽃무늬가 요란한 의상을 걸치고 등장한다. 그런가 하면 화려한 여행복과 테가 큰 요란한 모자를 착용한 큰 눈을 가진 이국 여인들이 이들과 어울린다. 진시황제가 거느렸던 궁중 여인들과 전성기의 로마 황제의 여인들이 21세기의 분장을 걸치고 다시 등장한 것 같다.

근작들은 이전의 '환상의 뮤직드림'을 다루던 시절을 전후해서 제작한 작품들 보다 한층 화려한 색채와 순도를 더한 컴포지션을 구사한다. 대다수의 작품이 청색조라면 삼분의 일 정도가 적색조다. 어느 작품일지라도 청적靑赤의 색상대비와 중간톤의 청자靑紫와 적자赤紫의 색상대비가 근간을 이룬다. 이보다 더는 밝은 톤과 어둔 톤의 명도대비가 화면의 뼈대를 구축한다. 작품들은 작가 자신이 이상형으로

생각하는 오데트와 지그프리드 왕자로 상징되는 북구 요정의 이야기를 현대버전으로 전치하는 맥락을 보여준다.

이를 내용의 기조로, 자신이 집시가 되어 다스리는 세상을 드라마풍으로 보여준다. 드라마를 회화적으로 번안하기 위해 화면의 전경은 연극 무대에서처럼 주인공이 자리하고, 중경과 원경은 차례로 조연들과 배경을 설정한다. 전경의 주인공은 클로즈업과 클로즈다운을 살려 영화의 스크린 기법으로 구성했다. 인물들과 소재들을 전중후로 서열하는가 하면, 상공에서 보는 부감시(over-looking-view)를 원용하고, 화면을 좌우로 나누는 균형구성을 구사했다. 일견 샤갈이 만년에 떠나온 눈 내리는 고향을 회상했던 선례를 상기시키면서도 이를 과감하게 그 자신의 것으로 전유하는 데 성공한다. 그럼으로써, 근작들은 생애의 후기를 맞는 작가가 자신이 걸어온 삶을 순연한 집시의 시선으로 바라보면서, 삶의 무한한 기쁨과 감사를 랩소디(rhapsody)로 번안한 화풍을 관객에게 선사한다.

작가가 작품에 등장시키고 있는 주인공들은 돌이켜 보면 모두가 그 자신의 자화상이다. 이들은 그 스스로가 마음에 묻어둔 젊은 날의 초상이다. 이는 작가가 자신의 옛 모습을 상상공간으로 불러들여 그 자신의 '아니마'(anima)를 그리는 자화상임에 틀림없다. 그녀의 아니마는 청순한 요정의 모습으로, 결코 어둡거나 노쇠하지 않다. 아주 젊은 아니마들이다. 그녀는 이들을 현재로 불러냄으로써 우리 시대의 이미지를 생산함은 물론, 대중들이 이를 감상하고 소비할 기회를 마련한다. 아니 적어도 이미지를 소비하는 사회현실을 간접적으로 풍자한다. 이것만으로도 그녀의 근작전은 우리의 구상화단에 신선한 충격을 선사하리라 확신한다.

2015, 5

파리의 연정
Love in Paris
53×45.5cm, Oil on Canvas, 2014

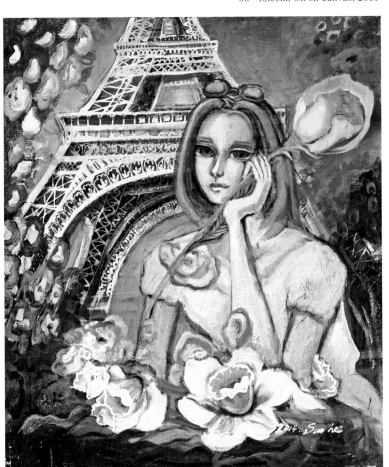

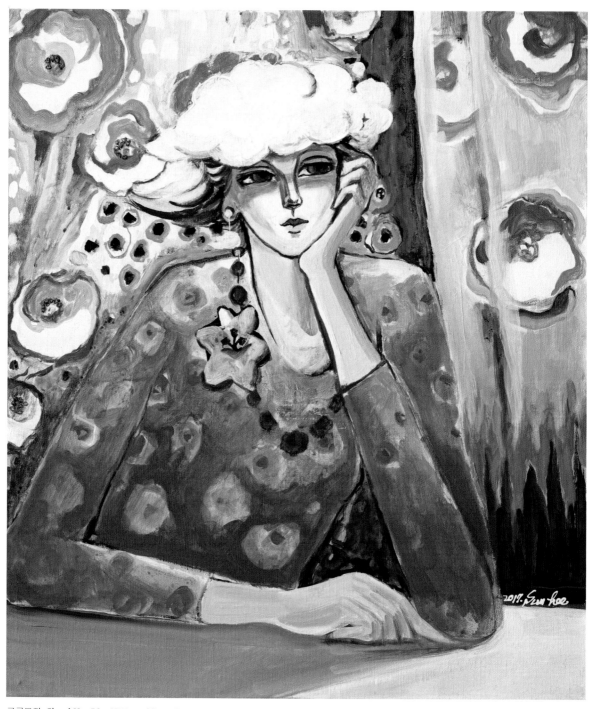

구름모자 *Cloud Hat* 53×45.5cm, Oil on Canvas, 2017

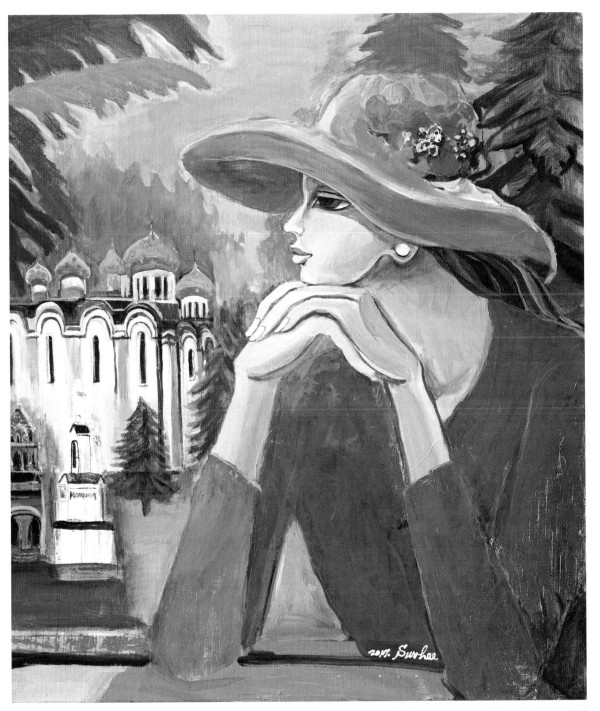

카페의 나타샤 *Natasha in Cafe* 53×45.5cm, Oil on Canvas, 2017

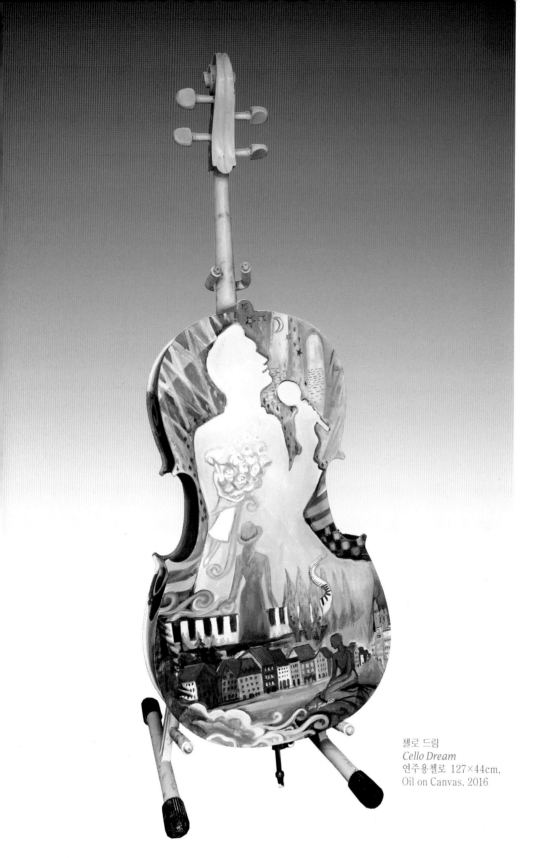

첼로 드림
Cello Dream
연주용첼로 127×44cm,
Oil on Canvas, 2016

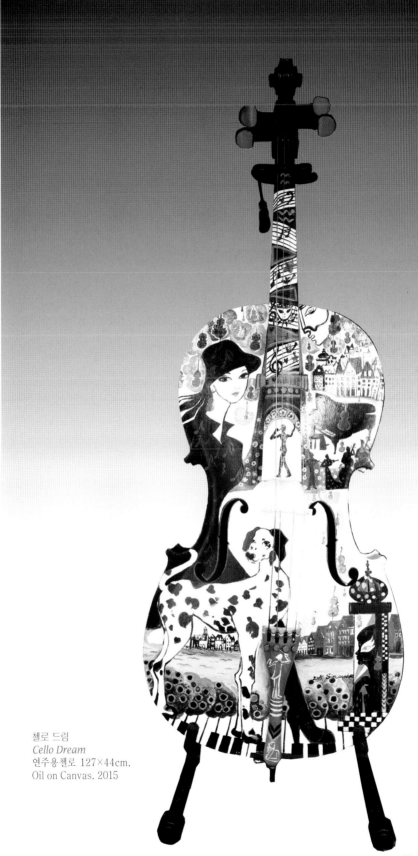

첼로 드림
Cello Dream
연주용첼로 127×44cm,
Oil on Canvas, 2015

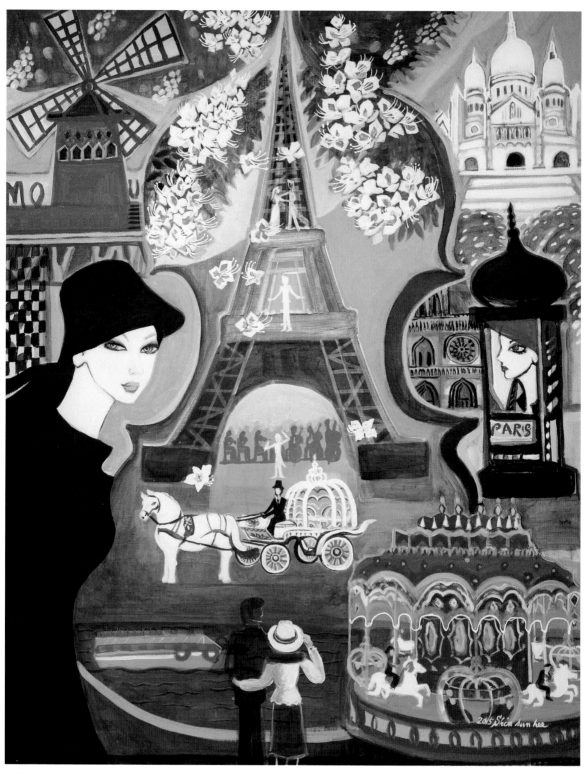

파리 내 사랑 *Love in Paris* 116.8×91cm, Oil on Canvas, 2015

The Portrait of Gypsy in our Times
— Shim Sun Hee's Exhibition of Recent Works

Kim Bok Young / Art Critic, Former Professor at Hongik University

1

When we talk about gypsy in paintings, we might recall <The Sleeping Gypsy> by Henri Rousseau (1844−1910). The background of picture is in the evening of ridge at sunset and dark twilight time. A gypsy girl who got tired of living fell asleep deeply and she has a mandolin next to her. A big lion was looking for something to eat, approached to her as it scented the gypsy, and stares at her. <The Dream> by Henri Rousseau is also similar to this scene. It's a pastoral picture. Instead of gypsy, a naked woman is lying down on a couch in a forest, a dreary snake moves its body under the forest and some reed flute sound is suddenly heard from somewhere

As his name means, Rousseau was born with the nature of Bohemian who wanders around with dark brown hairs and swims like a sea bream or carp fish. He retired from customs officer and then was immersed in painting. Painting was the best resting place for him to

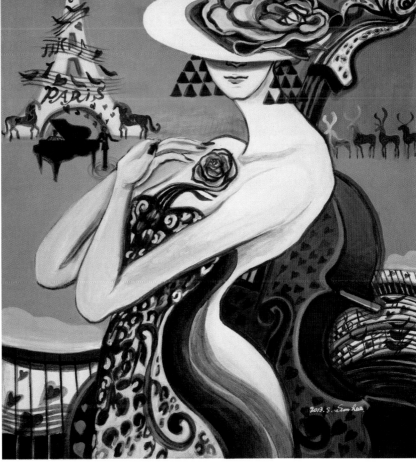

뮤직드림 *Music Dream* 90.9×72.7cm, Oil on Canvas, 2013

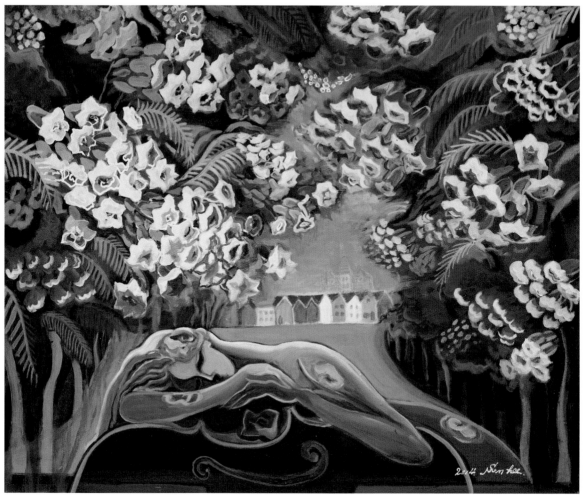

자카렌다
Jakarenda
72.7×50.5cm, Oil on Canvas, 2012

support the freedom of life. He chose painting only with his nature as a method of enjoying freedom although he had never learned how to paint. His artworks immediately aroused sensation in the art world. The artists who recognized him was not those around Ingres who were influential but others so-called 'the blue' around Picasso who painted poor old couples and clowns. They were the pure sensitive artists like Gauguin who went that far away (Tahiti) as he left behind then stiff salon style. They were instantly trembled at Rousseau's paintings and applauded with moved hearts.

2

By the time of artist Shim Sun Hee's exhibition, I speak of Rousseau first because these two artists have something emotionally in common. Like Rousseau did, Shim became an imaginary gypsy herself and went around the world. She has painted about sceneries and customs with pure emotions. These two artists have the same

style of life in terms of the motive and method of painting.

Her pictures are splendid gypsies which could be painted by a professional artist who studied painting at university unlike the poor gypsies painted by Rousseau. As if giving a blow with the eyes of unaffected Bohemianism, she paints about the world in our era, the height of abundance. Her pictures show a phase of the 21st century that the material civilization runs extreme. Like Rousseau did, she also longed for freedom in imagination since she was little and wandered aimlessly around the world as she became adult. She has described the loneliness of people she met while traveling like a dreaming gypsy and the hidden side of the affluent life. We could find her inherent gypsy disposition in her words "One day, I visited Moscow with my mother for sketch trip and I met innocent gypsy family there whom I felt homogeneity. (「Note」 2015)".

Her recent works deal with largely three themes. One is about the things she had met in the journey to the white night Moscow and Ermitazh museum in Saint Petersburg. Another is the experimental theme that she saw on the Sibelius train toward Helsinki Finland which passed along the birch forest and lake up to the purple colored

뮤직드림
Music Dream
72.7×50.5cm, Oil on Canvas, 2013

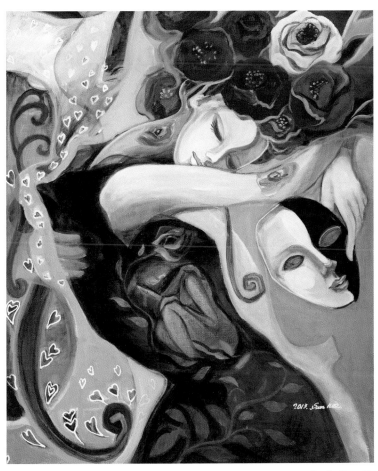

fantasy of Fjord in Norway and meeting with the Mermaid in Denmark. Plus, the materials from the Northern and Western Europe, Canada, America, Southeast Asia, and the South Pacific that had imprinted on her are crossed over. The last theme is about music trips in the cities which the artist has loved so much. These artworks are communions of music and painting that she translated the inspirations from the chanson in Notre Dame de Paris, the popera songs in the musicals such as the Phantom of the Opera, the Jekyll and Hyde, the Last Empress, and Sweeney Todd, and the concerts of mixed tenors.

3

The artist transforms the materials taken from gypsy travels mostly into prima donnas on a splendid stage. A cellist, a white piano and a pianist in white dress, a vocalist in white dress or a black

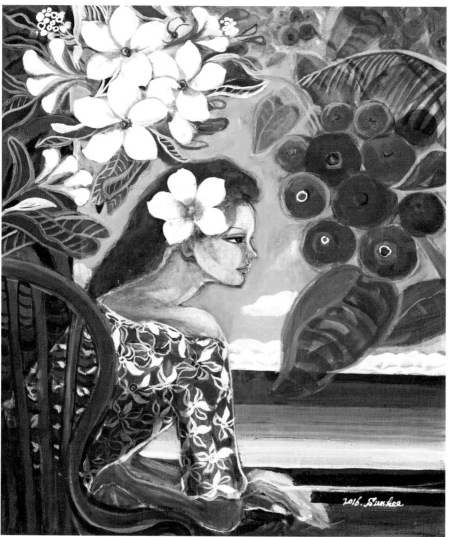

남태평양의 키샤
Kisha in the South Pacific
53×45.5cm, Oil on Canvas, 2016

piano and a pianist in black dress, and a vocalist in black dress appear as the main characters with the same level. In addition, she puts flower coach, deer, the Eiffel Tower, a Persian palace with splendid dome, nameless flowers and fish, luxurious wine table, flower patterned clothes, fancy bedroom and carpet on the background which look mysterious like a world of fantasy. The highly pure blue tone and red tone colors are flamboyant. A prima donna, a cellist, or a pianist are wearing loud flower patterned clothes. Even more, the exotic women in fancy travel outwears and wide hats with big eyes hang out with them. It seems the court ladies of Emperor Qin and the ladies of Roman Emperor appear again as they wear the 21st century's costumes.

Her recent works show more colorful tones and purity of composition than the former works which she dealt with 'the fantastic music dream.' Most of her works are in blue tone while one third is red tone. Every work has color contrast of blue and red, and also the contrast between blue-purple and red-purple which are medium colors. Moreover, the brightness contrast between bright tone and dark tone constructs frame on the canvas. The works displace fairytale stories of the Northern Europe symbolized as Odette and Siegfried, which is her ideal type, into some modern version.

With this story as basis, the artist became a gypsy and rules the world in this drama on canvas. In order to translate the drama into picture, the foreground of canvas is taken by the main character as

in a drama stage, and the supporting actors and background are at the medium and distant views. The characters at foreground are formed with the movie screen technique with close-ups and close-downs. The people and materials are arranged at the front, in the middle, and at the back. Even more, the over-looking-view from the air is cited, and the balanced composition divides a canvas into left and right. At a glance, it reminds us Chagall's reminiscence of the snowy hometown but Shim succeeded in daringly appropriate this as her own. Thereby, Shim's recent works are a

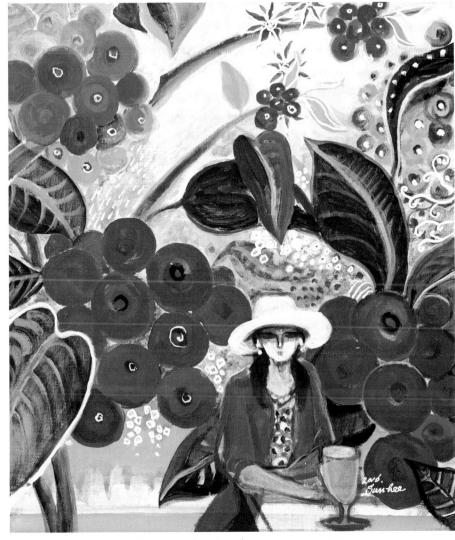

팔라우의 카페
Cafe in Palau
53×45.5cm, Oil on Canvas, 2016

gaze at her whole life which she has walked through with the view of pure gypsy, and offer the painting style of rhapsody which sings infinite joy and appreciation of the life to spectators.

If we look into the characters on her paintings, they are all the artist's portraits. They are the portraits of her young days that she has buried in her heart. These must be her portrait of 'anima' which she invites her look of old days to the imaginary space. Her anima looks like an innocent fairy and she is never dark or gets old. They are very young animas. She invites them to present and not even generates the image of our days but also provides the chances for the public to appreciate and consume them. At least, they indirectly satirize social reality that consumes images. This is sufficient to be sure that her exhibition will offer a fresh impact to the world of representational paintings. − May 2015

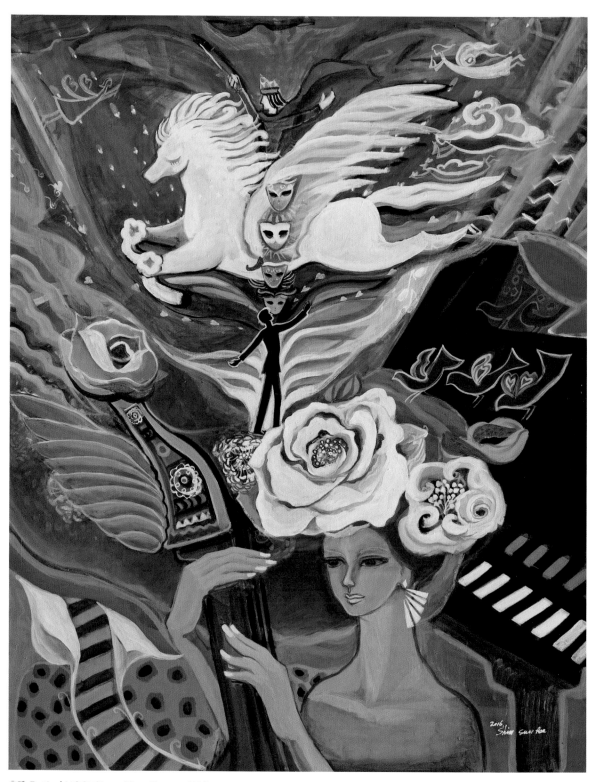

축제 *Festival* 116.8×91cm, Oil on Canvas, 2016

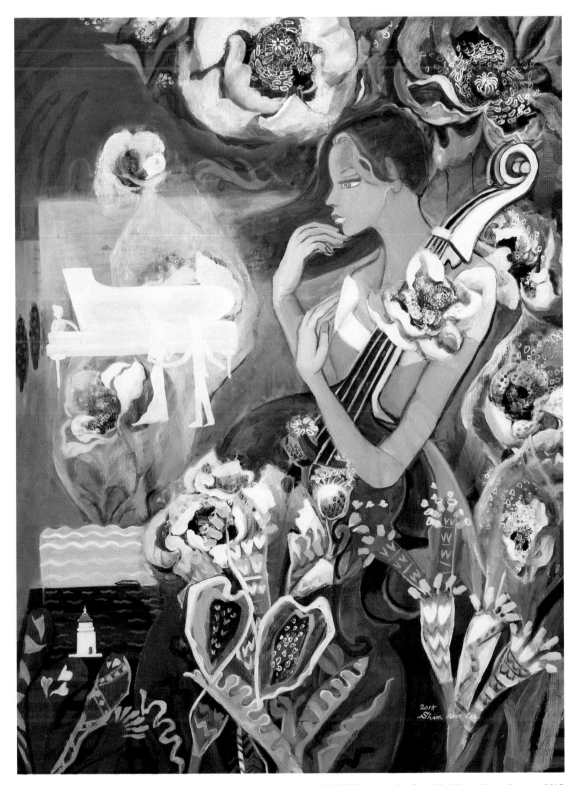

시크릿 가든 *Secret Garden* 132×97cm, Oil on Canvas, 2015

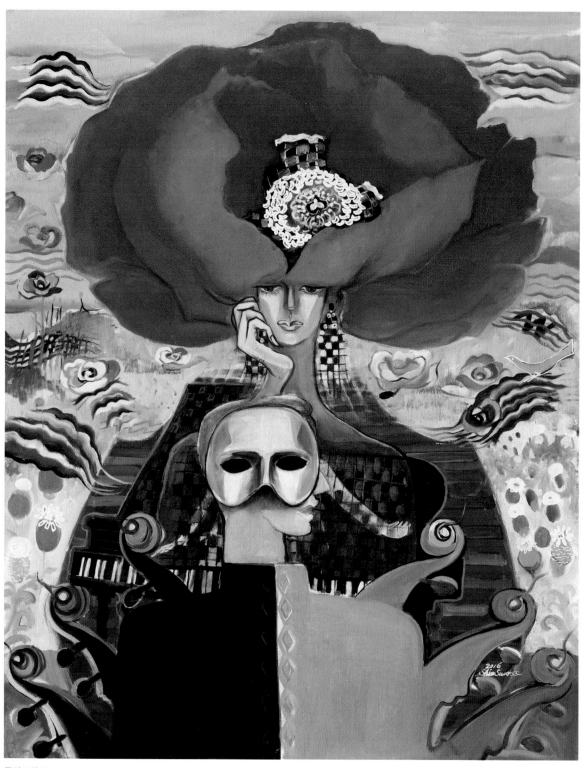

뮤직드림 *Music Dream* 116.8×91cm, Oil on Canvas, 2016

이상향의 구현

작품 속에서 꿈과 욕망을 찾아

신항섭 / 평론가

누구나 현실에서 충족되지 못한 욕망이 실현될 수 있다는, 이상향에 대한 꿈을 지니고 산다. 그 욕망은 실현가능성이 낮을수록 더욱 강렬한 꿈으로 작용하기 마련이다. 예술가의 경우는 창작을 통해 그 욕망을 실현하고자 한다. 다시 말해 승화된 현실로서의 이상향을 작품 속에서 구현하고자 한다. 그래서 그림 속의 욕망이란 언제나 비현실적이기 십상이다. 승화된 현실로서의 욕망을 목표로 하는 까닭에 비현실적일 수밖에 없다. 심선희의 그림에 나타나는 꿈은 현실을 기반으로 하지만 언제나 달콤하고 환상적이며 낭만적인 이미지로 귀결한다. 그의 그림은 비현실성, 즉 환상적인 이미지로 가득하다. 어쩌면 환상적으로 보이는 것은 이국적인 정서에 기인하는지 모른다.

분명히 그 자신의 일상적인 삶의 체험에 근거하는데도 정작 그림에서는 이국적인 정서로 표현된다. 물론 실제로 외국여행을 통해 보고 느낀 풍정을 제재로 하는 작품도 적지 않다. 이는 그 자신의 꿈과 욕망이란 현실을 벗어난 지점, 즉 낭만적인

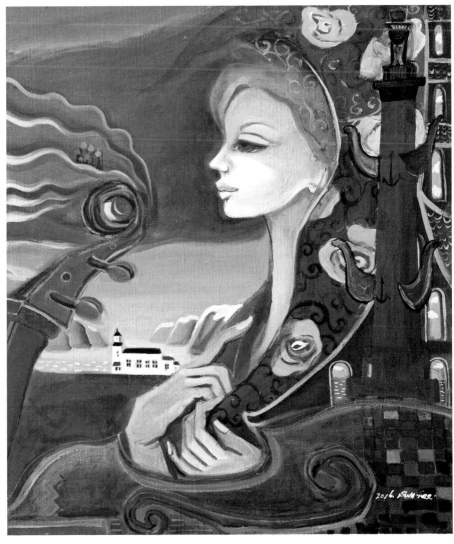

등대
Lighthouse
53×45.5cm, Oil on Canvas, 2016

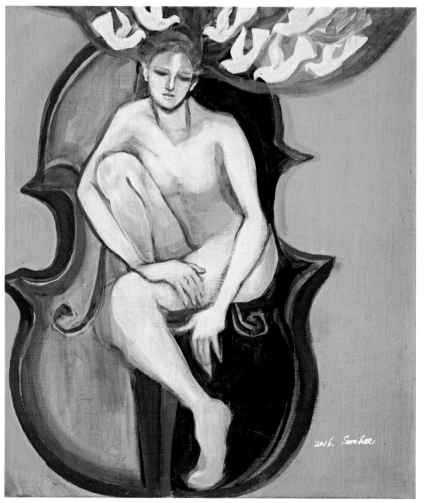

첼로드림
Cello Dream
53×45.5cm, 2016

이국적인 정서를 겨냥하고 있음을 뜻하는 것은 아닐까. 때로는 현실에서의 일탈이란 현실과 완연히 다른 이국적인 삶일 수도 있겠기에 말이다.

그렇다. 환상적이고 이국적인 정서는 꿈과 욕망의 배출구일 수도 있다. 그러기에 이국적이면서도 환상적인 이미지로 꾸며지는 것이리라. 아름다움에의 욕망에 의해 가공된 현실은 필경 비현실성, 즉 환상적인 이미지가 될 수밖에 없다. 그는 환상적인 이미지를 통해 승화된 현실을 꿈꾸고, 그 곳에 자신만의 왕국을 건설하려는 것이다. 그 꿈의 왕국은 여성적이면서도 우미하고 고요한 사색의 공간이 된다. 여인, 꽃, 달, 해, 악기, 나무, 말, 그리고 이국의 풍경과 그 곳의 사람들이 그림의 소재 및 대상이 된다. 이들 소재는 그 자신의 욕망과 꿈의 실현을 구체화시키는데 필요한 조형언어로 연출된다.

여성으로서의 아름다운 삶에 대한 욕망은 온갖 번잡한 일상으로부터의 일탈을 그 시발점으로 한다. 생활의 굴레로부터 벗어나 진정한 정신적인 독립 및 해방을 위해 자기만의 세계를 꿈꾸는 것이다. 그의 그림은 이와 같은 개인적인 욕망의 실현을 위한 돌파구인 셈이다. 그리하여 현실적인 문제를 떠나 상상 및 환상의 공간으로 잠입한다. 거기에서 그는 누구로부터도 침해받지 않는 절대적인 영혼의 자유를 맛보며 꿈과 같은 사유의 공간을 유영한다.

어쩌면 집시를 대상으로 한 작품이 큰 비중을 차지하는 것도 우연은 아니다. 어디에도 얽매이지 않고 이리저리 떠돌아다니는 집시의 자유로움이야말로 이상적인 삶의 형태일 수도 있기 때문이다. 어차피 인간 삶이란 정착하지 못하는 부평초와 같은 것이고 보면, 집시의 삶을 동경하는 것은 결코 부질없는 짓이 아니다. 특히 자유정신을 절대가치로 여기는 예술가적인 삶의 입장에서 볼 때 무소유의 삶의 방식을 고집하는 집시는 이상적인 존재일 수 있는 것이다.

그런가 하면 음악이 있는 삶 또한 그의 이상적인 세계관, 또는 예술관에 합당한 제재이다. 추상적인 언어로서의 음악을 실제의 연주회장에서 만났을 때 시각적인 이미지에 묻어오는 음악에의 감동은 새삼 삶의 아름다움 및 진정성을 일깨워준다. 또한 다양한 형태의 음악회는 정신 및 감정의 고양을 부추기는 것이다. 그런 아름다운 시간에 대한 체험은 억제하기 어려운 창작 충동으로 이어지게 마련이다.

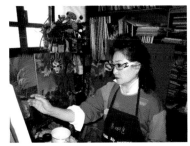

이렇듯이 그의 그림은 개인적인 꿈과 열망 그리고 자유를 위한 헌사라고 할 수 있다. 달리 말해 예술이라는 이상적인 세계관을 향한 열정의 산물이다. 그래서일까, 그의 그림에서는 삶이 흔히가 넘친다 주체하기 힘든 감동으로부터 비롯되는 순정한 삶에 대한 헌시가 꿈처럼 그려지고 있다. 그의 그림에는 그런 감동을 전제로 하는 시적인 정서가 가득하다. 그에게 아름다움이란 시각적인 이미지만을 의미하는 것은 아니다. 순수한 추상적인 언어인 음악이 그렇듯이 눈에 보이지 않는 미적 가치 역시 그에게는 외면할 수 없는 아름다움인 것이다. 뿐만 아니라, 정착하지 않고 떠돌아다니는 삶을 운명적으로 받아들이는 집시들의 삶의 방식도 그에게는 놓칠 수 없는 아름다움이다

그의 그림은 유채인데도 첫인상으로는 전통적인 채색화처럼 보인다. 그것은 부드럽게 처리하는 표현방식과 무관하지 않다. 유채가 가지고 있는 물질적인 느낌, 즉 질감을 피해 곱게 처리하기 때문이리라. 이러한 묘사기법은 환상적인 분위기를 만드는데 효과적이다. 더구나 형태를 단순화하고 왜곡하는 그의 작품에서는 비현실성을 강조하는 시각적인 효과를 나타내기 때문이다. 그런데다가 색채이미지는 대담한 보색대비를 마다하지 않을 만큼 강렬하다. 작품마다 특정의 색채이미지를 중심으로 그에 상응하는 보색을 배치함으로써 비현실성을 강조하고 있다. 독특한 색채배열은 현실적인 공간개념을 떠난 자유로운 구성 또한 환상적인 분위기를 만드는데 일조를 한다.

굳이 여성이 아니더라도 누구나 그의 그림과 더불어 달콤한 꿈의 확장을 모의할 수 있다. 그의 그림에는 우리의 미적 감수성과 정신적인 자유를 부추기는 미묘한 장치가 곳곳에 숨어 있기 때문이다. 그 장치란 시각적인 아름다움이라는 절대적인 가치 위에서 피어나는 풍부한 예술적인 상상이다. 그가 연출하는 다채로운 상상의 세계로 환상여행을 떠나보자.

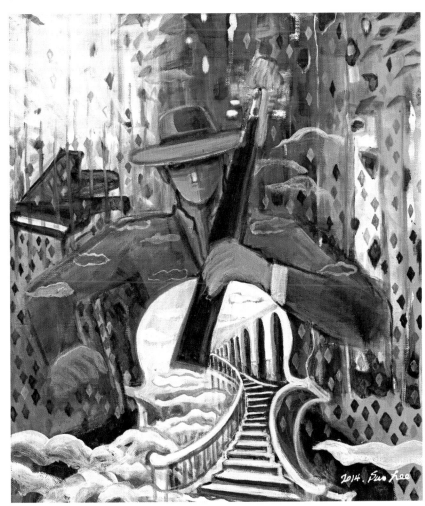

첼로드림
Cello Dream
53×45.5cm, Oil on Canvas, 2014

시크릿 가든 콘서트
Secret Garden Concert
90.9×72.7cm, Oil on Canvas, 2014

Critique by Shin Hang Seob

Anyone lives with a dream for the utopia where unfulfilled desires in reality may be realized. If the desire has low chance to be realized, it tends to become more a stronger dream. In case of artists, they try to realize such desire through creation. In other words, they try to materialize the utopia in the artwork as a sublimated reality. Therefore, the desire in painting always tends to be unrealistic. Because its aim is the desire which is sublimated reality, it can be only unrealistic. The dreams in Shim Sun Hee's paintings are based on dreams but they are always concluded as sweet, fantastic, and romantic images. Her paintings are filled with unreality, namely fantastic images. Maybe they look fantastic because they come from exotic sentiments.

Apparently, they are based on her daily life experiences but her paintings express them with exotic sentiments. Of course there are many paintings about the appearance that she has seen and felt through traveling to overseas. They might aim the point where her dream and desire have passed over reality, namely the romantic exotic sentiment. Sometimes, departure from the reality could be an exotic life which is obviously different from the reality.

Indeed. The fantastic and exotic sentiments may be the outlet of dream and desire. Therefore, they might be decorated as exotic and fantastic images. The reality processed by the desire for beauty can only be unreality, namely fantastic image. Shim tries to dream the reality sublimated through fantastic image, and build her won kingdom in there. The dream kingdom is feminine, graceful, and calm place for meditation.

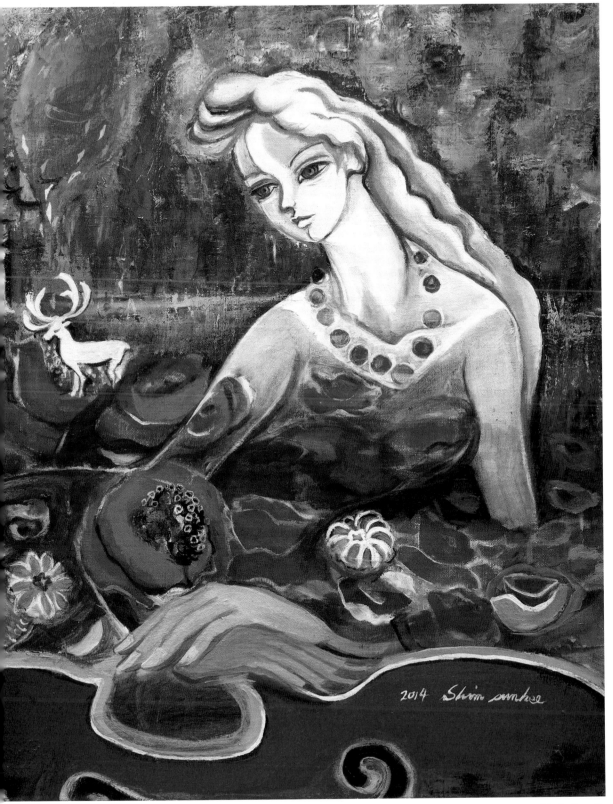

2014 Shim sunhee

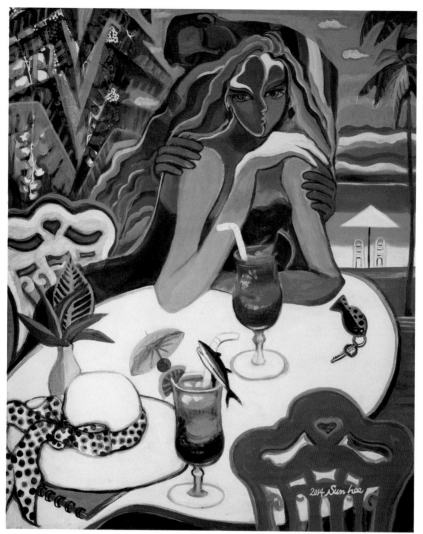

로맨틱 남태평양
Romantic Palau
90.9×72.7cm, Oil on Canvas, 2014

The woman, flowers, the moon, the son, musical instruments, trees, horses, and exotic landscapes and people become the materials and objects of the paintings. These materials are directed as formative language to materialize her own desire and dream to be realized.

The desire for beautiful life as a woman starts from departure from complicated daily life. She dreams of her own world for genuine mental independence and liberation as she escapes from the restriction of life. Her paintings are the breakthrough to realize her personal desire. Thus, she departs from problems in reality and sneaks into the space of imagination and fantasy. In there, she tastes the absolute freedom of soul without invasion by anyone else and wanders around the dream-like space of meditation.

Probably, it is not coincidence that the paintings about gypsy takes a large part of her artworks. The unconventionality of gypsy who wanders around without being restricted to anything could be an ideal form of life. Anyway, the life of human is like a floating weed which can't settle down, so it is not a useless thought to long for the life of gypsy. In particular, in the aspect of artist who thinks liberal mind is the absolute value, the gypsy who insists non-possessive life can be an ideal being.

Furthermore, the life with music is another topic of her ideal view of the world, or the view of the art. When we meet music as abstract language at an actual performance hall, the impression of music which comes with the visual image awakes the beauty and authenticity of life. Moreover, diverse forms of musical concerts boosts our mind and emotions. Such experiences for beautiful times leads to uncontrollable urge to create.

As such, Shim's paintings are dedications for personal dreams, desires, and freedom. In other words, they are the fruits of passion for the ideal view of world, the art, Therefore, her paintings are full of joy of life. She paints with overwhelmed impression like dreamy poems for pure life. Her paintings are filled with such poetic emotions based on the impressions. For Shim, beauty doesn't mean only visual images. As music, the pure abstract language, does, the invisible artistic value is also a beauty for her not to be disregarded. In addition, the life of gypsy which is to accept the wandering life as fate, is also a beauty not to be lost for her.

로맨틱 팔라우
Romantic Palau
53×45.5cm, Oil on Canvas, 2015

Shim's artworks are oil paintings but they look like conventional colored pictures at a first glance. It may be related to her soft and gentle expression method. Probably she strokes gently as escaping the texture and substantial feeling of oil paints. Such technique is effective to make fantastic mood. Even more, they get visual effect of emphasizing unreality which simplifies and distorts forms. Furthermore, the color images are very strong with daring complementary contrasts. She arranges complementary colors around certain color images for each artwork to stress the unreality. Such unique color arrangement also helps make fantastic mood with liberal composition escaped from realistic spatial concept.

Anyone, even not female, can conspire the expansion of sweet dream with Shim's paintings. Her paintings hide delicate devices at every corner which evoke artistic sensibility and mental freedom. The device is abundant artistic imagination blossomed on the absolute value called visual beauty. Let's go on a fantastic trip to the colorful world of imagination created by Shim.

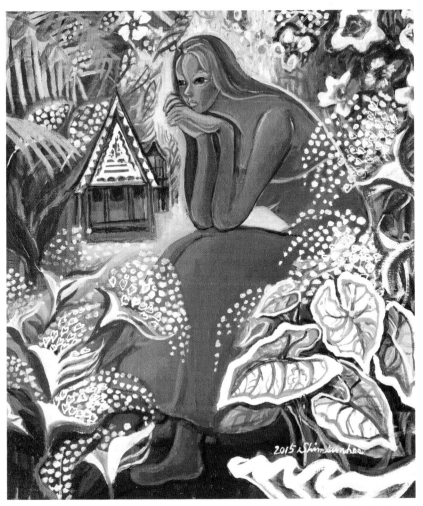

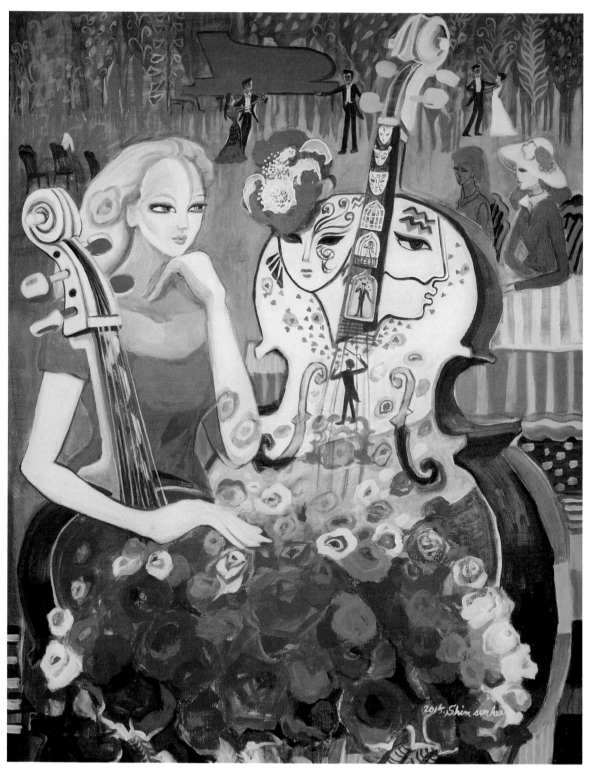

뮤직드림 *Music Dream* 116.8×91cm, Oil on Canvas, 2015

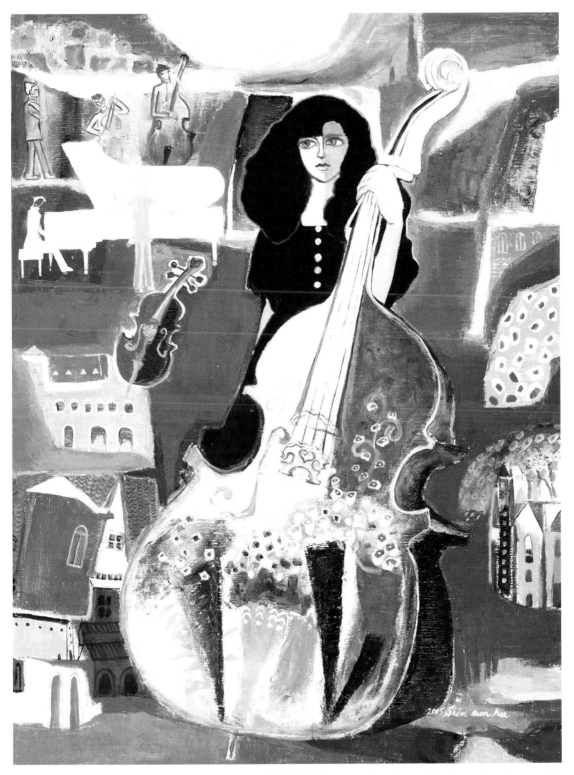

집시의 뮤직드림 *Gypsy's Music Dream* 130×97cm, Oil on Canvas, 2015

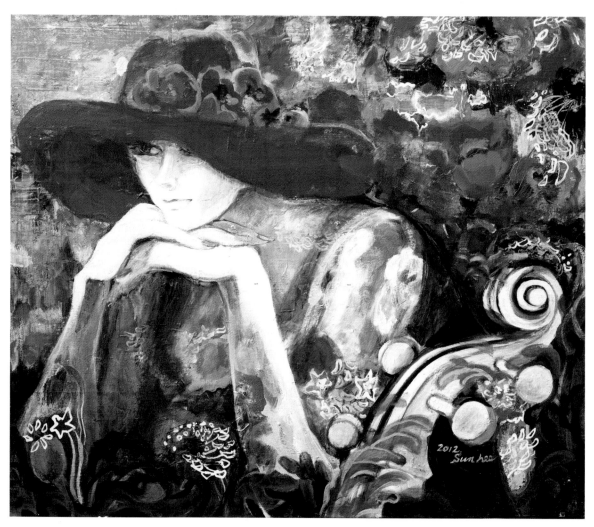

뮤직드림
Music Dream
53×45.5cm, Oil on Canvas, 2012

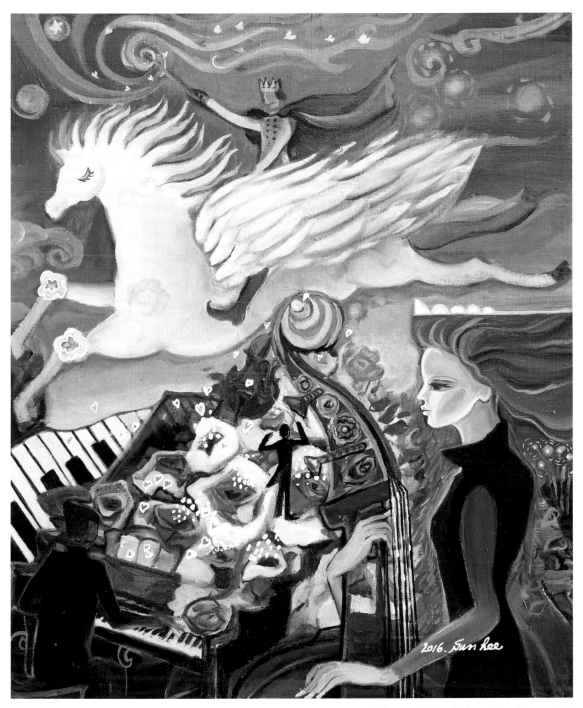

축제 *Festival* 72.7×60.6cm, Oil on Canvas, 2016

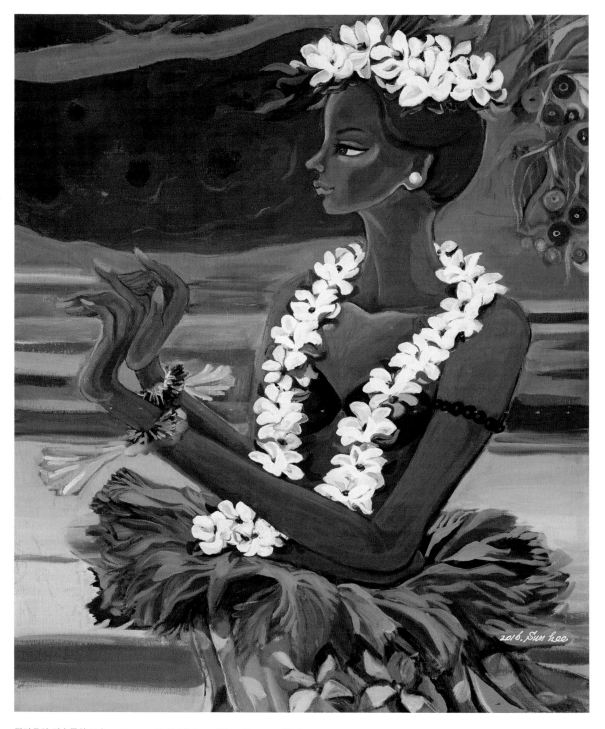

필라우의 민속무희 *Palaus Dancer* 72.7×60.6cm, Oil on Canvas, 2016

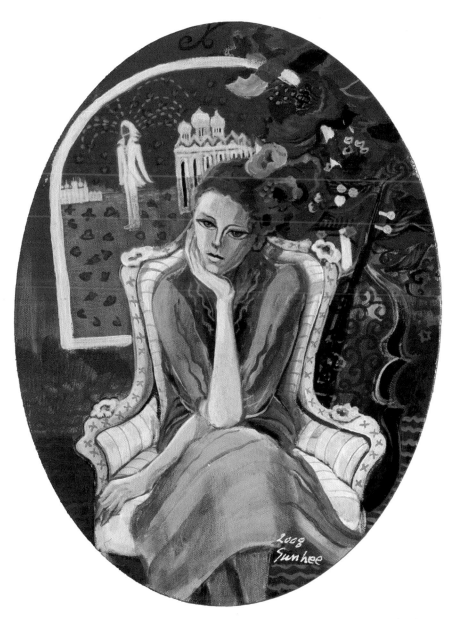

음악축제 *Music Festival* 30×45cm, 아크릴, 2008

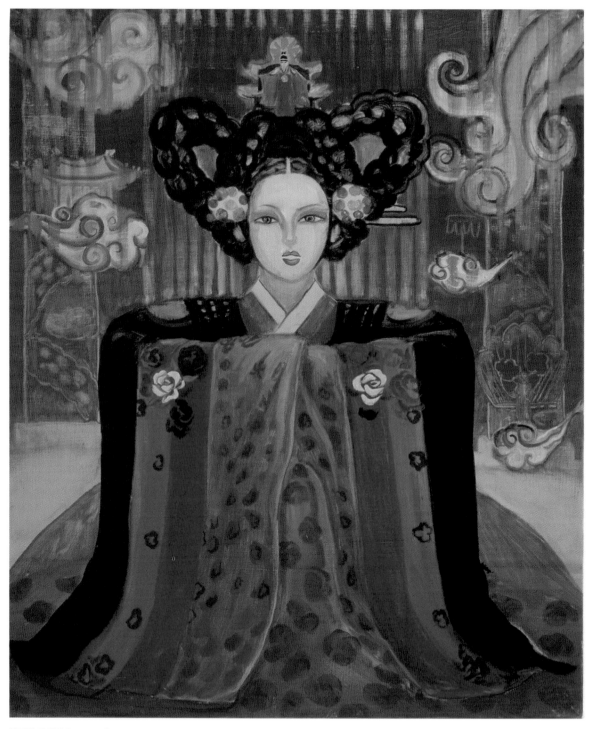

뮤지컬 명성황후 *Musical Queen Myeong Seong* 72.7×60.6cm, Oil on Canvas, 2009

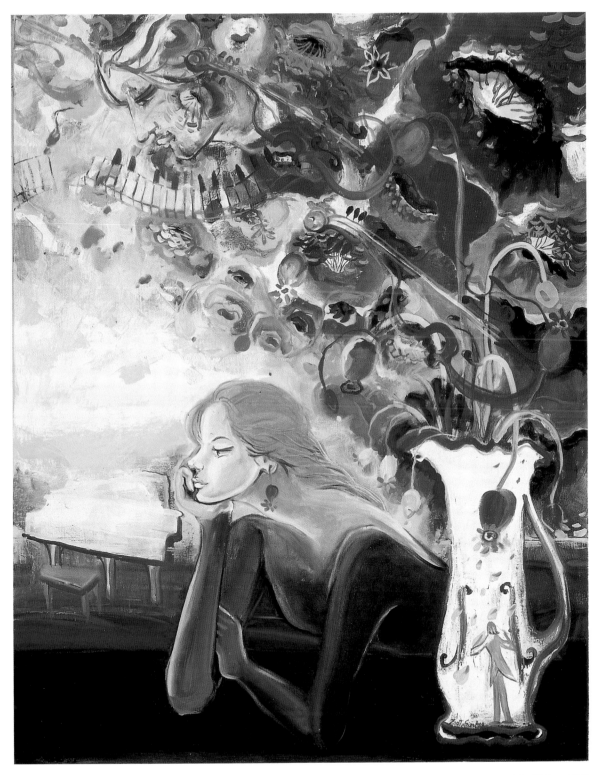

환상의 뮤직드림 *Fantastic Music Dream* 90.9×72.7cm, 2009

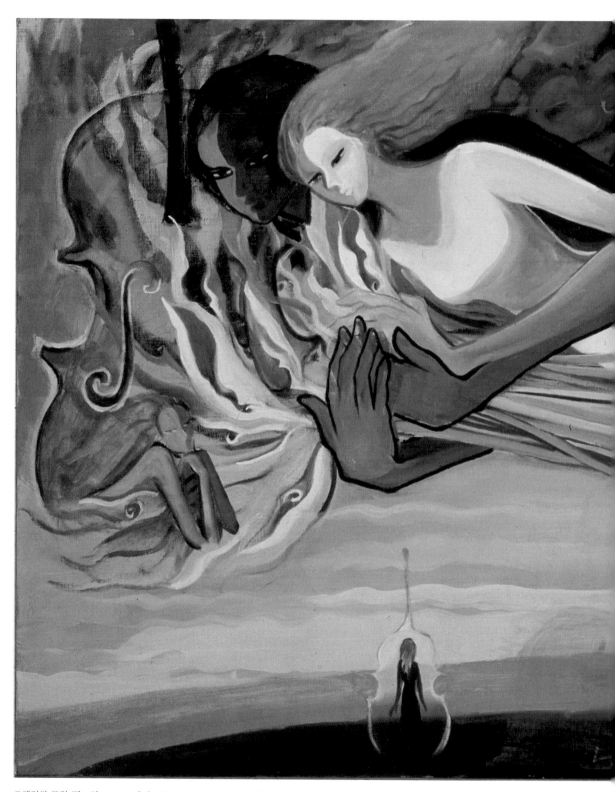

오페라의 유령 *The Phantom of The Opera* 72.7×121.5cm, Oil on Canvas, 2009

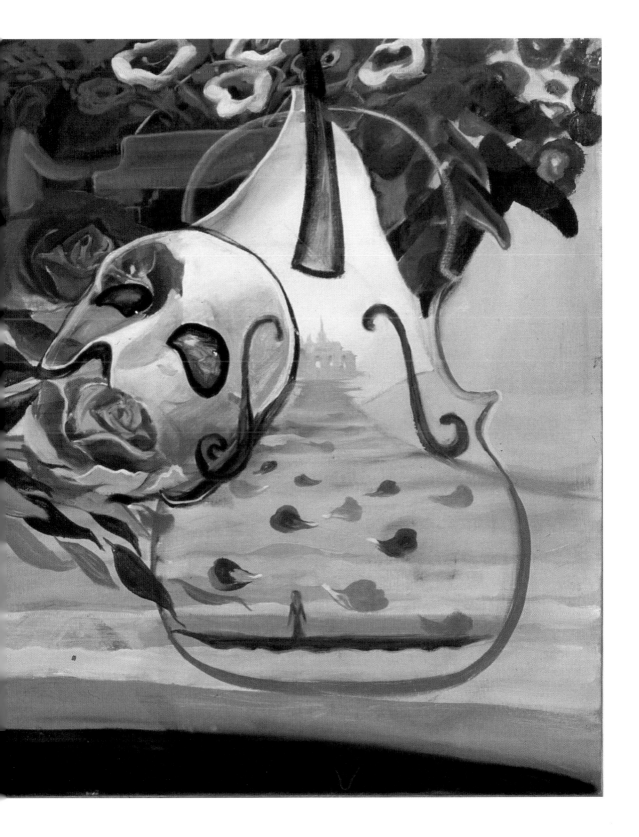

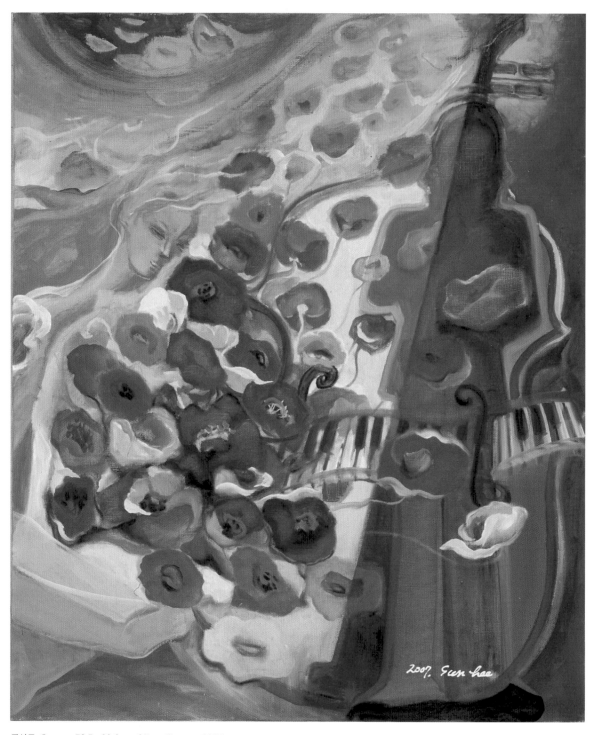

콘서트 *Concert* 72.7×60.6cm, Oil on Canvas, 2007

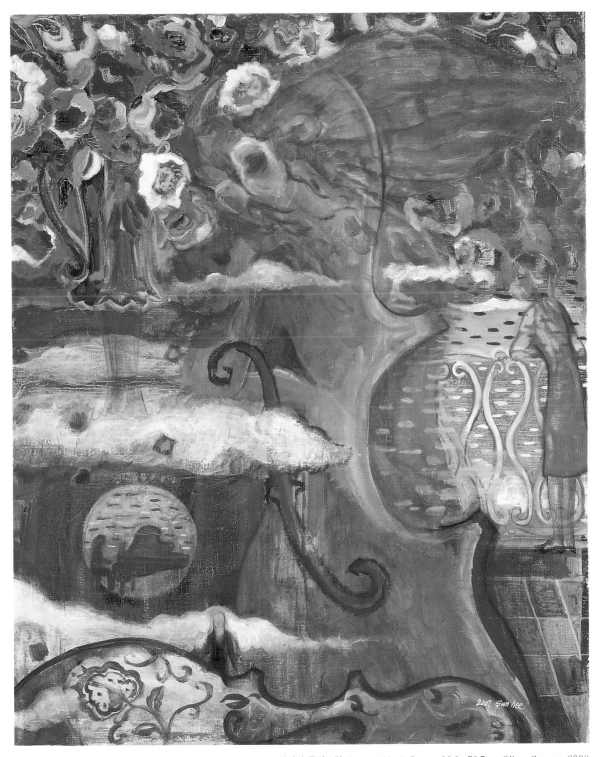

환상의 뮤직드림 *Fantasy Music Dream* 90.9×72.7cm, Oil on Canvas, 2008

축하의 글

2015년 5월
서양화가 전명자

산록의 빛이 짙어가는 5월에 그간 조용히 자신만의 작품세계를 구축하여 온 심선희씨의 근작전.

항상 주변의 모든 사물을 아름답게 표현하며 뜻을 부여하여 오신 작가의 일련의 작품들 중에서 특별히 첼로와 꽃을 주제로 한 장미화를 보여줌으로 복잡한 도시생활 속에서 잊혀가는 자연에 대한 그리움과 향수를 불러일으킬 수 있는 꽃과 인간의 신비함을 환상적으로 그려내고 있다.

그 신비한 산호색과 노랑, 빨강, 주황색을 넘어 어딘가 작가의 예술혼을 직접 느낌으로, 작가의 이상적 모습으로 마치 혼과 숨결이 담긴 듯한 특징 있는 작품들을 창출한다고 말하고 싶다

심선희의 전체적인 작품 세계의 특징은 섬세한 사실력을 바탕으로 투명하면서 시적인 서정성을 구사 하는 것인데, 전체적으로 밝고 평화로운 느낌에 집중시키고 있는 점은 감상자로 하여금 서정적 미감을 심리적으로 느끼게 하기 위해서일 것이다.

심선희의 작품은 색조와 명도에 관한 그의 심미안을 훔치르르하게 드러내는 일련의 현란한 화폭들을 펼쳐 보인다.

하늘에 맞닿은 여러 장미꽃, 몽환적이고 섬묘하기도 하며 직관적이기도 할 뿐만 아니라 정염한 온유가 흠뻑 배인 무염 무애한 심안을 통하여 수렴된 최초의 감성을 재현한 화풍임에 틀림없다.

심선희의 작품들은 금세 흘러내릴 듯한 꽃들이 상단의 형상과 대비될 뿐만 아니라 서로 길항하는 느낌처럼 환상미의 효과를 물씬 창출해낼 만큼 아스라이 융화된 채색으로 특징지어진다.

작가의 대단한 집념과 굳은 의지 가운데 꼭 성공하는 열쇠를 가지고 있지 않나 생각하며, 미래를 보다 풍성한 것으로 만들 것이다.

없는 길을 여는 것이 예술가의 길!

강변축제
Gangbeyeon Festival
22×27.5cm, Oil on Canvas, 2009

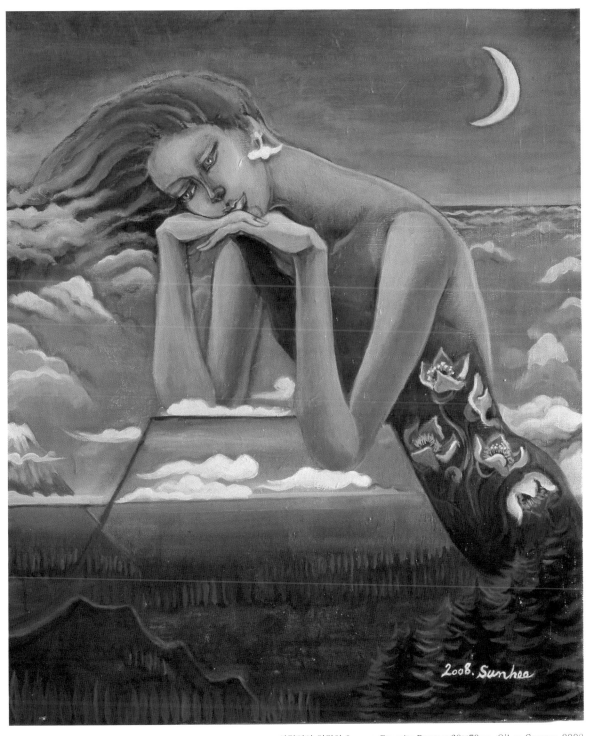

사랑이여 영원히 *Love or Eternity Forever* 60×73cm, Oil on Canvas, 2008

Congratulations on the Exhibition

May 2015

Artist Jun MyungJa

Shim Sun Hee's exhibition of her own world of arts is held in May when the season gets greener.

Shim has always expressed every objects around her beautifully. Among them, the rose painting with a cello and flowers as theme evokes the yearning and nostalgia for nature which we might loss in the complicated city life. And she describes the flowers and human's mysteriousness fantastically.

Somewhere beyond the mysterious coral color, yellow, red, and orange, the painter's artistic soul is directly felt here, and she creates unique artworks which contain her soul and breath with her ideal look.

Shim's overall peculiarity of art world is based on delicate reality while making use of transparent and poetic lyricism. On the whole, the paintings focus on bright and peaceful feeling which is probably for lyrical esthetic sense in mind for the spectators.

Shim's artworks also show a series of splendid scenes that reveal her eye for tone and brightness.

The roses touching the sky look not only dreamlike and intuitive but also must be the style that realizes the first emotions collected through immaculate and boundless eye for beauty soaked with burning passion of gentleness.

음악여행
A Musical Tour
40.9×28cm, Oil on Canvas, 2007

Shim Sun Hee's artworks show the contrast of flowers running down from above and also have the feature of color harmony which can even create the beauty of fantasy like the feeling of antagonism.

Maybe the artist has the key of success in her great tenacity and strong will, and they will make the future more abundant.

An artist should open a new road!

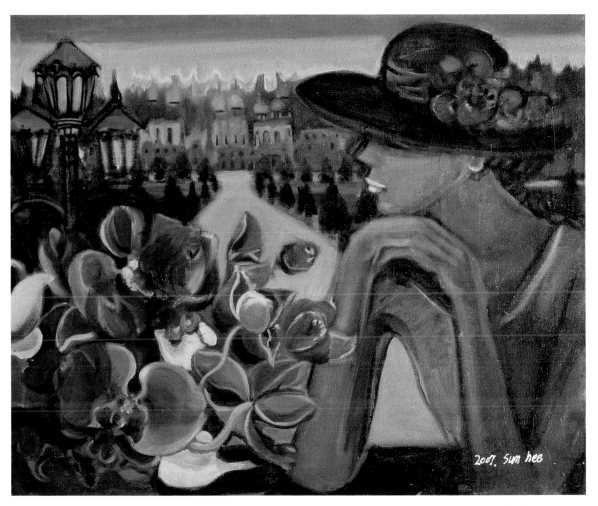

스웨덴 스톡홀름의 집시
Stockholm, Sweden Gypsy
53×45.5cm, Oil on Canvas, 2007

강변의 음악여행 *A Riverside Journey* 63.5×49cm, Oil on Canvas, 2007

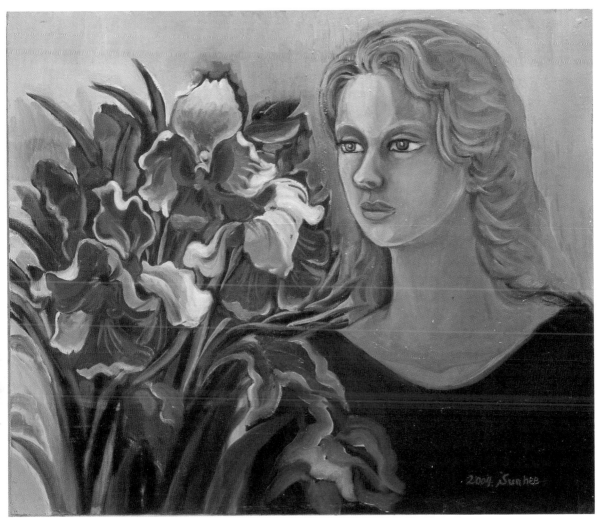

모스크바의 나타샤 *Natasha in Moscow* 53×45.5cm, Oil on Canvas, 2007

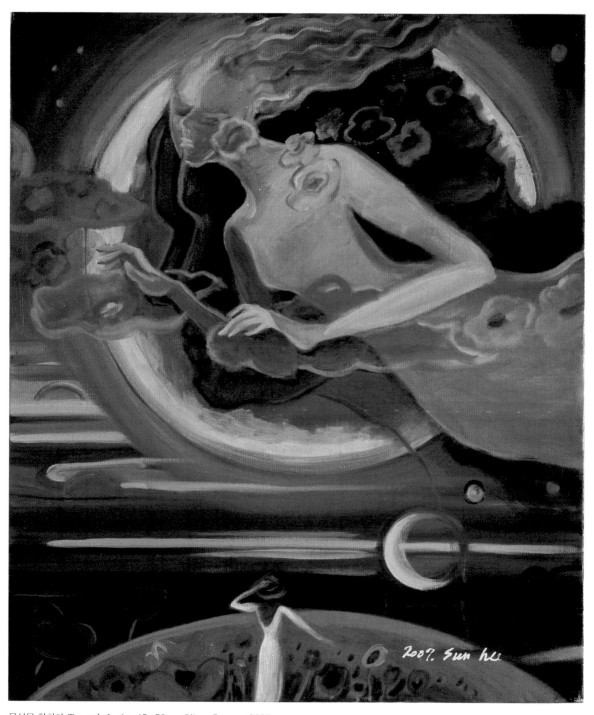

목성을 향하여 *Towards Jupiter* 45×53cm, Oil on Canvas, 2007

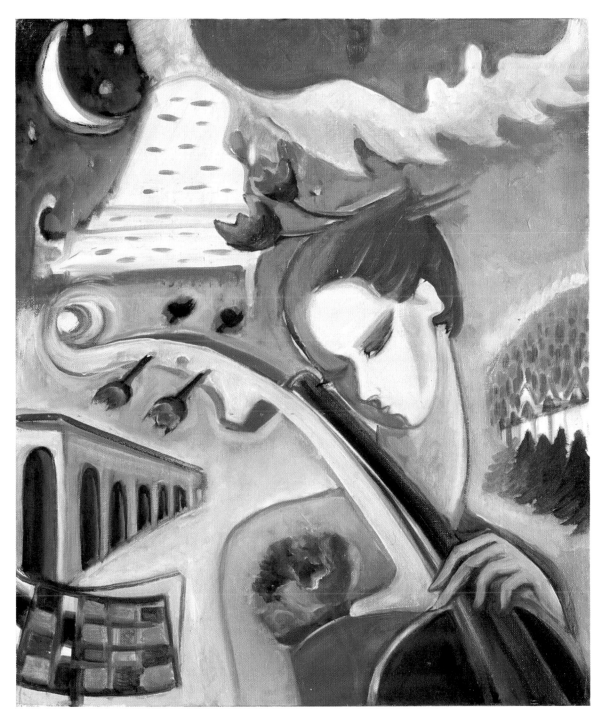

넬라 판타지아 *Nella Pantajia* 53×45cm, Oil on Canvas, 2007

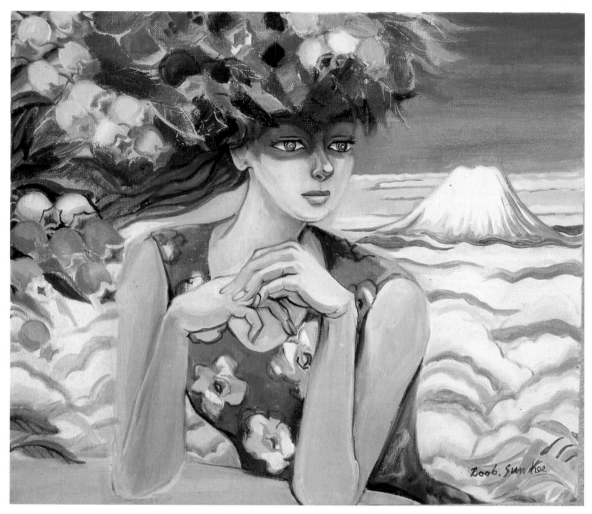

하꼬네 여정 *Hakkone Journey* 53×45.5cm, Oil on Canvas, 2006

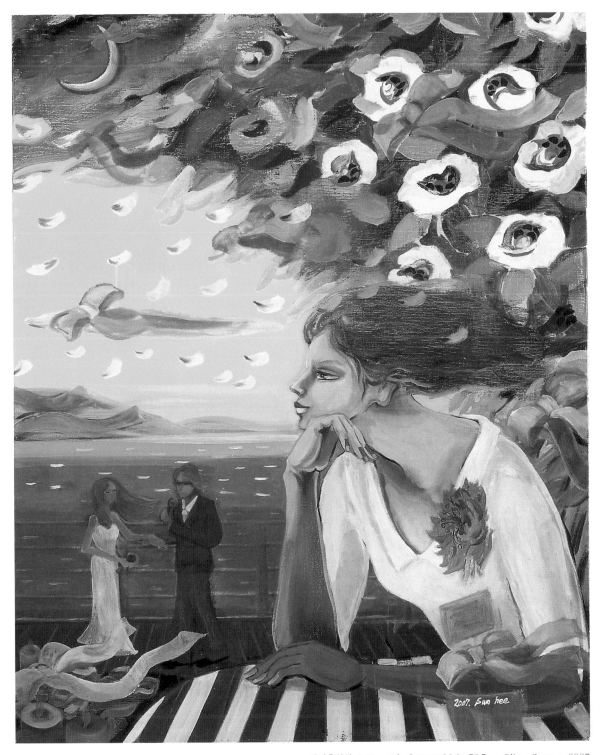

강변음악회 *A Riverside Concert* 90.9×72.7cm, Oil on Canvas, 2007

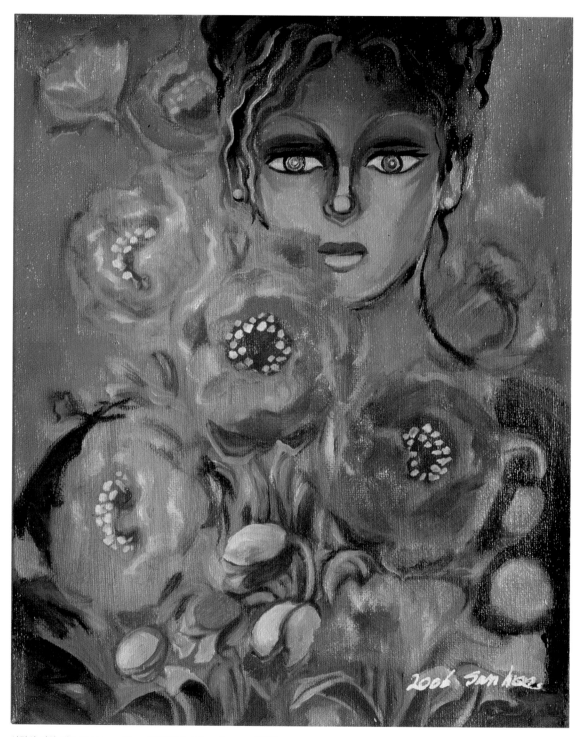

사랑의 기억 *The Memory of Love* 53×45.5, Oil on Canvas, 2006

집시
Gypsy
53×45.5cm, Oil on Canvas, 2006

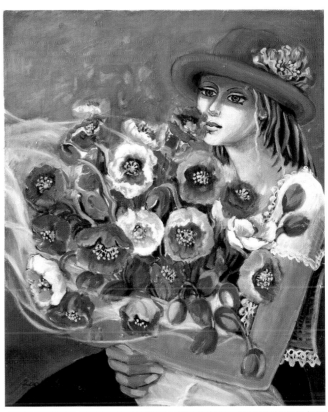

뮤직드림
Music Dream
53×45.5cm, Oil on Canvas, 2007

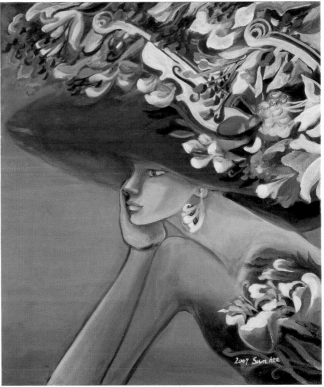

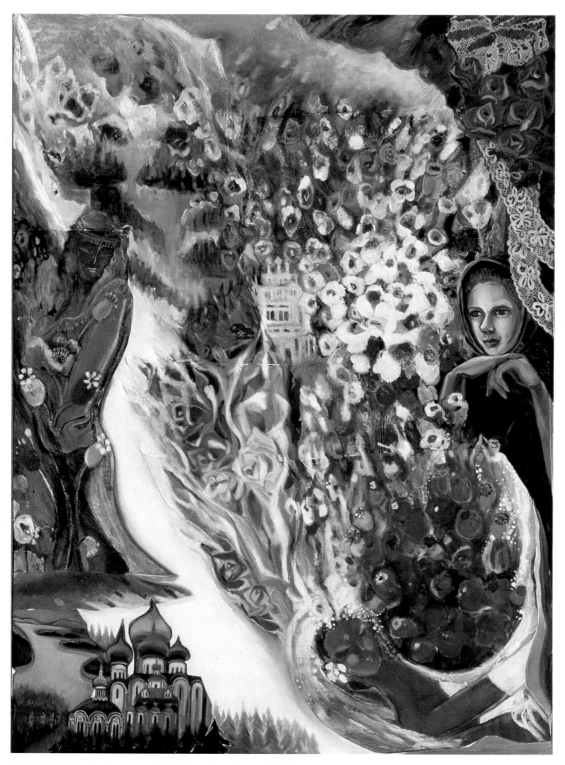

북유럽의 여정 *The Nordic Journey* 131×92cm, Oil on Canvas, 2006

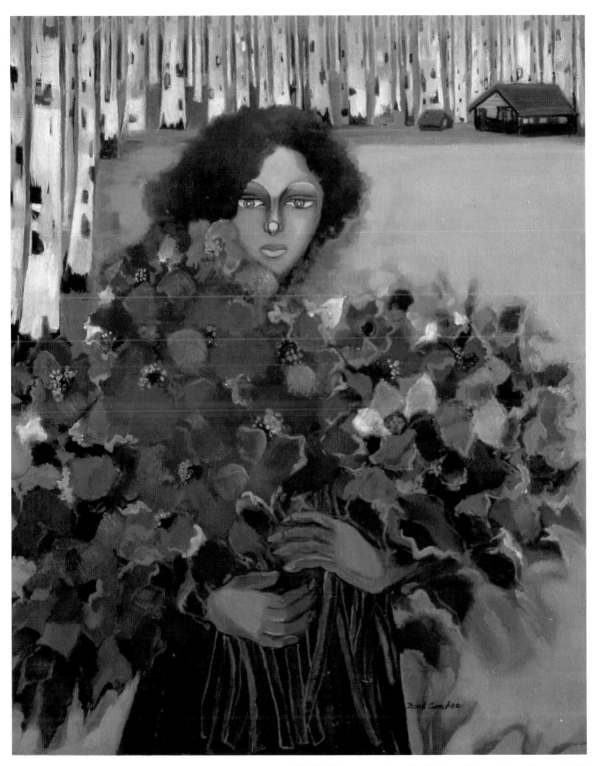

백야의 집시 *Gypsy in the Midnight* 92.5×90.5cm, Oil on Canvas, 2006

내 친구 심선희

화가 정강자

나는 이 지면을 빌어 심선희의 작품에 대하여 평하려는 것이 아니다.

평론은 전문 평론가 선생님들의 몫. 하지만 이 세상 그 어떤 평론가도 쓸 수 없는 이야기를 하고 싶다. 나만이 쓸 수 있는 그런 이야기, 바로 나의 가장 친한 단짝 친구에 대해 말하려 한다. 누군가가 나더러 세상에서 가장 친한 친구 한 사람만 대보라고 한다면 난 1초의 주저함도 없이 '심선희' 라고 대답할 것이다. 두말할 필요도 재고의 여지도 없음이다.

대학시절 그 풋풋했던 기쁜 우리들의 젊은 날들을 선희와 나는 실기실에서 같이 뒹굴며 그림자처럼 붙어 다녔었다. 집이 부산이었던 선희는 신촌 로터리

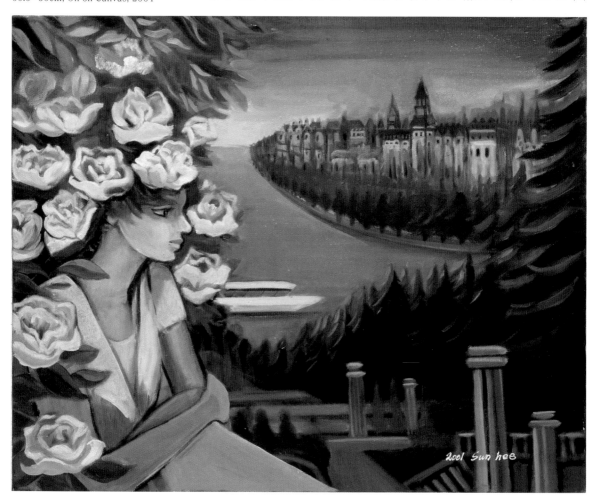

스웨덴의 집시
List of Sweden Gypsies
60.6×50cm, Oil on Canvas, 2004

근처에서 방을 얻어 자취를 했고, 나는 돈암동에 사는 오빠네 집에서 전차를 타고 마포 종점까지 와서 밭두렁을 걸어 홍대 뒷문으로 다녔다. 선희는 언제나 깨끗하고 윤기가 나는 피부에 예쁜 얼굴과 쪽 곧은 다리가 정말 매력적이었다. 그러나 더 아름다웠던 것은 착하고 고운 그녀의 마음이었다.

지금 돌이켜보면 그 당시 아름다운 그녀에게 반한 학생회장과 몇몇 강사님들의 인기를 한 몸에 받고 있던 그녀에게 선머슴 같은 나는 은근히 샘도 났고, 반항적인 기질을 핑계로 이따금 선희에게 핀잔도 내뱉었지만 선희는 늘 잘 넘겨주었다.

그러나 무엇보다도 기억에 남은 건 함께 미친 듯이 열심히 그림을 그렸었다는 추억이다.

당시 우리 과는 프랑스에서 돌아오신 박서보 교수님이 주임 교수로 계셔서 새로운 표현을 하는 데 열린 편이었다고 기억한다. 하지만 불행히도 대한민국 미술의 미래를 열어가야 할

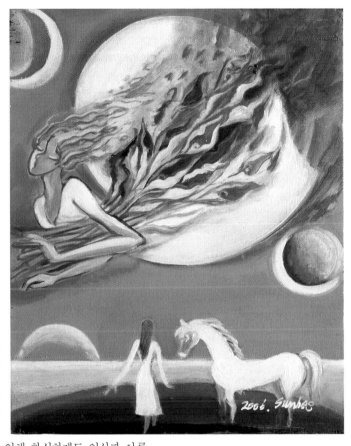

목성을 향하여
Towards Jupiter
41×32cm, Oil on Canvas, 2006

대학에서조차 우리는 선진국(미국, 프랑스, 영국, 일본 등)에서 일어나고 있는 새로운 미술에 대해 듣지도, 보지도 아예 감지조차 할 수가 없었다. 게다가 당시 세계 미술의 흐름이었던 팝아트 같은 새로운 물결에 대해서는 누구도 꿰뚫는 사람이 없었다. 우리 반을 제외한 나머지 세 반은 여전히 일본 유학을 마치고 온 교수님들로 인해 한심하게도 인상파 아류를 답습하고 있었다.

선희와 나는 새로운 것에 대해 늘 목마름이 있었지만 끝내 그 갈증을 적시지 못한 채 졸업을 했다. 서로가 있었기에 더욱 즐거웠던 대학시절이 끝나는 졸업식 날, 서로를 바라보며 지었던 말없는 미소. 그 속에 담긴 수많은 의미들 가운데 가장 컸던 감정은 아쉬움이었으리라.

졸업 후 선희와 난 돈암동 우체국 2층에 세를 얻어 본격적으로 작업을 시작했고 새로운 작업, 기존 세대에 대한 반발, 개혁을 가져올 그 무엇을 표현하는 도전에 몰입했다. 때마침 대학 선배 정찬승이 찾아왔다. 우리는 그가 제안한 '청년작가 연립전'의 한 축인 '신전동인'의 핵심 멤버가 된다. 그 연립전에 선희는 입체 설치작품 '미니'를 출품하였고, 나도 입체 설치작품인 'Kiss me'를 출품했다. 우리들이 출품한 설치작품들이 당시 한국 미술계를 뒤흔든 센세이셔널의 큰 부분이었음을 돌이켜보는 지금 이순간도 당시의 흥분이 되살아나는 느낌이다.

그러나 기쁜 우리 젊은 날은 영원하지 않았다. 선희와 나는 각자 서로의 삶을 사느라 많은 세월을 떨어져 지낼 수밖에 없었다. 선희의 작품에는 그녀의 만만찮은 삶을 고스란히 담았다. 그녀는 여행에서 만난 이국적인 풍경들, 집시들의 고달픈 모습들, 그리고 남태평양 바다 속의 신비한 풍경들을 담아냈고 또 "음악" 역시 그녀의 그림 소재로 자주 등장하는데 음악에 관한 대부분의 영감들은 사실 팝페라 테너 박완의 열광적인 팬으로서 그녀가 10여 년 간 그의 음

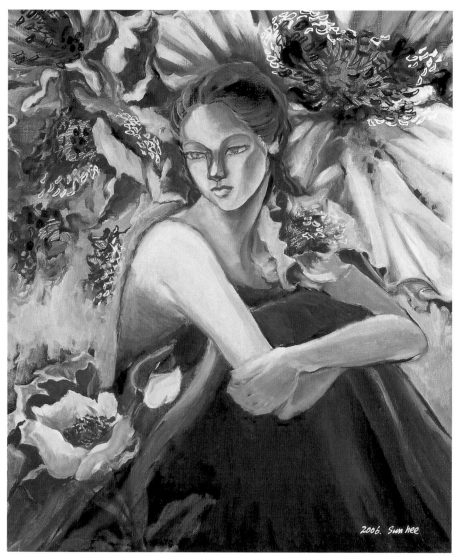

백야
Midnight Sun
60.5×72.5cm, Oil on canvas, 2006

악으로부터 받은 것이다. 그런 인연으로 세종문화회관에서 열렸던 '팝페라테너 박완 화음(畵音) 콘서트'는 선희의 작품이 박완의 노래와 어우러진 이른바 그림과 음악의 완벽한 콜라보를 완성하기도 했는데. 세종문화회관의 넓은 무대 위에서 펼쳐진 선희 특유의 환상적인 그림들은 정말 탄성을 자아내게 했다. 이 공연에 쏟아진 수많은 관객의 박수는 비단 박완을 향한 것만은 아니었다. 그의 음악과 어우러진 선희의 그림들이 감동의 시너지를 만들어냈음은 누구도 부정할 수 없는 사실이다. 앞으로 박완 뿐 아니라 다른 음악가들과의 새로운 콜라보도 계속 기획하고 작업한다면 화음(畵音) 콘서트라는 장르에서 독보적인 존재가 되리라고 나는 믿는다.

선희야

우리들의 젊은 날 꿈꾸었던 거대한 탑을 아직 다 쌓지도 못했는데 어느덧 우리 앞에는 마지막 황혼이 붉게 타오르고 있다. 아니, 이제서야 예술이 무엇인지, 미술이 무엇인지 조금 알 것 같은데 너와 난 시간이 별로 많지 않은 나이가 되었구나.

세상에는 영원한 것이 없다고 하지만. 너와 나의 우정만큼은 예외로 남기고 싶구나.

사랑한다 친구.

2017년 2월

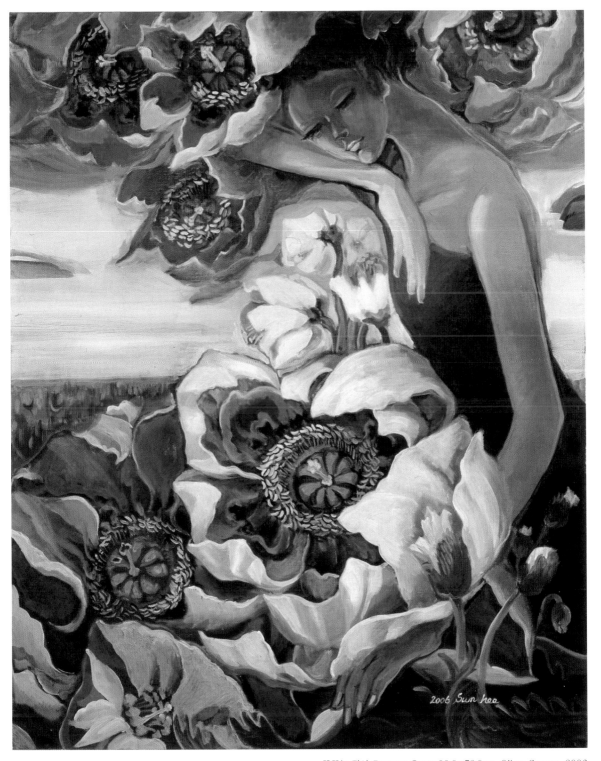

꿈꾸는 집시 *Dreamy Gypsy* 90.9×72.9cm, Oil on Canvas, 2006

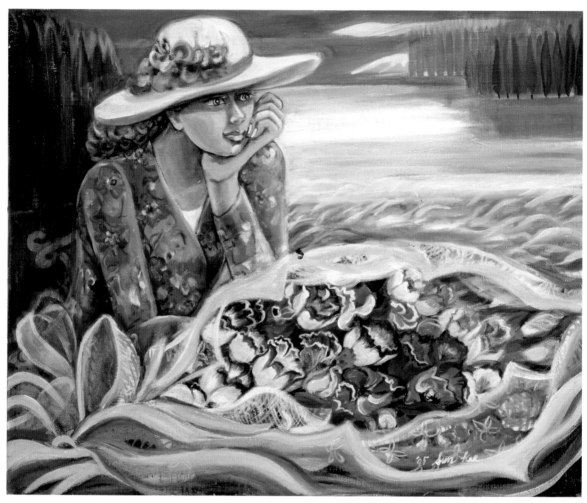

에메랄드 호수
Emerald Lake
72.7×60.6cm, Oil on Canvas, 2002

모스크바 공항의 집시
Gypsy at the Moscow keuba Airport
53×45.5cm, Oil on Canvas, 2006

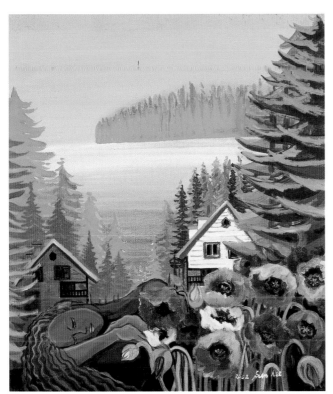

에메랄드 호수 *Emerald Lake* 53×45cm, Oil on canvas, 2002

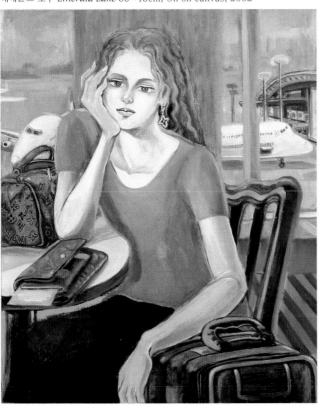

My friend Shim Sun Hee

Artist Jung KangJa

I am not trying to criticize about Shim Sun Hee's artworks here.

The professional critics would do the critiques. However, I would like to tell a story which not a single critic in the world can do. The story can be told only by me. This is about my best friend. If someone asks me who my best friend in the world is, I can say it's Shim Sun Hee without hesitation, not even a second. It is needless to say.

During our happy and young college days, Sun Hee and I were always together in the studio. Sun Hee's hometown was in Busan, so she rented a room near Shinchon rotary and lived by herself. I lived in Donam—dong at my brother's house and came to the last stop in Mapo by streetcar, and then I passed through the field behind the rear gate of Hongik University. Sun Hee always had clean and shiny pretty face with attractive and beautiful legs. But the more beautiful thing of her was kind heart.

As I remember now, maybe I was a little jealous of her because she so beautiful and loved by the student president and several instructors while I was like a tomboy. Maybe sometimes I scolded her with my defiant feelings but Sun Hee was always kind to me.

Above all, I remember the most that we were always crazy for paintings. At that time, our professor Park Seo Bo returned to Korea from France and he was somewhat

opened to new methods of expressions. Unfortunately, however, even at the university where should open the future of Korean art, we couldn't see, hear, or even detect the new art movement from advanced countries (the U.S., France, the U.K., Japan, etc.). Furthermore, no one had the insight for the new wave such as pop art which was the flow of art in the world during that era. Except for our class, the other three classes still pitifully followed the imitator of impressionist under the professors who had studied in Japan.

Sun Hee and I were always thirsty for something new but we couldn't satisfy it and graduated from university. We were happy because we had each other. On the graduation day, we looked at each other and smiled. Maybe the biggest feeling we had was regret among many meanings.

After graduation, Sun Hee and I rented a studio on the second floor of post office building in Donam-dong and began the serious

에메랄드 호수
Emerald Lake
60.6×50cm, Oil on canvas, 2004

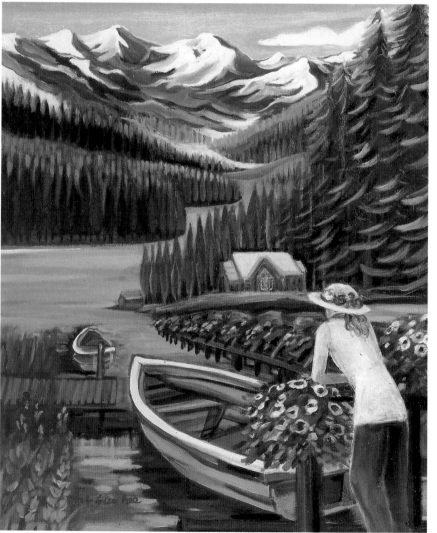

works of art. We were immersed in the challenge of expressing something new which will bring reformation as it resists against the existing generation. At that time, our senior alumnus Jung Chan Seung visited us. He suggested us to become core members of 'Sinjeondongin' which is an axis of 'the Exhibition of Young Artists' Union.' At the exhibition, Sun Hee submitted 'Mini', a three-dimensional installation artwork, and I also submitted a three-dimensional installation work 'Kiss me.' I still feel excitement when remembering that time because our installation works were sensational which shook the world of Korean art.

However, our happy young days didn't last eternally. Sun Hee

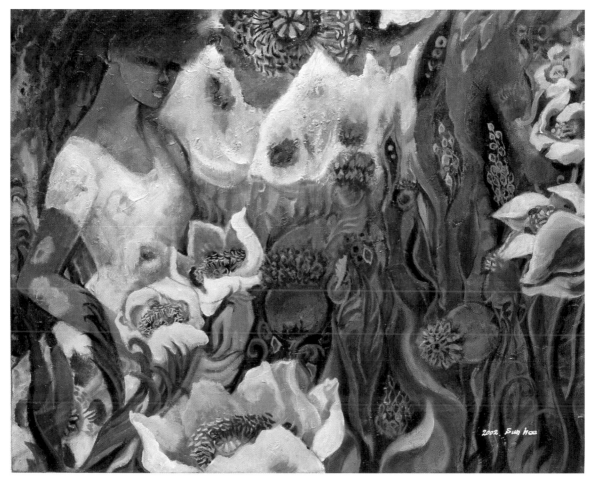

시크릿 가든
Secret Garden
90.9×72.7cm, Oil on Canvas, 2002

and I had to live separately as we should have our own lives to live. Sun Hee's artworks contain her tough life. She has painted exotic landscapes, tired looks of gypsies, and mysterious scenes under the sea of South Pacific which she has met while traveling. Moreover, she often uses 'music' as the material for her paintings. Most inspirations related to music were in fact from the Popera tenor Park Wan since Sun Hee has been a big fan of him for about ten years. With such great relation, Sun Hee's paintings made a perfect collaboration with Park Wan's songs at the 'Popera Tenor Park Wan's Concert' performed at Sejong Center for the Performing Arts. Sun Hee's fantastic paintings on the large stage of Sejong Center elicited exclamations from the audiences. The loud applauses after concert were not only toward Park Wan. Everyone would agree that Sun Hee's paintings made impressive synergy with his music. I believe that Sun Hee will become an unrivaled artist in the area of collaboration with music if she continues such works not only with Park Wan but also with other musicians.

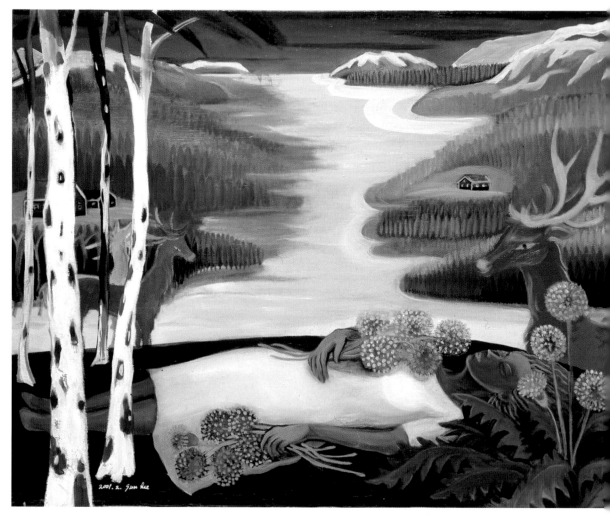

노르웨이 피요르드의 집시
Gypsy of Norway
116.7×90.9cm, Oil on Canvas, 2001

Dear my friend Sun Hee,

We haven't finished piling up the giant tower as we dreamed in the younger days, but now we see the sunset ahead of us. I mean, now we start understanding a little about art and painting, but we are old and don't have much time left.

People say there's nothing eternal in the world. But I would like to say the friendship between you and me is an exception.

With love to my friend.

February 2017
Sim Sun Hee' s friend Jung Kang Ja

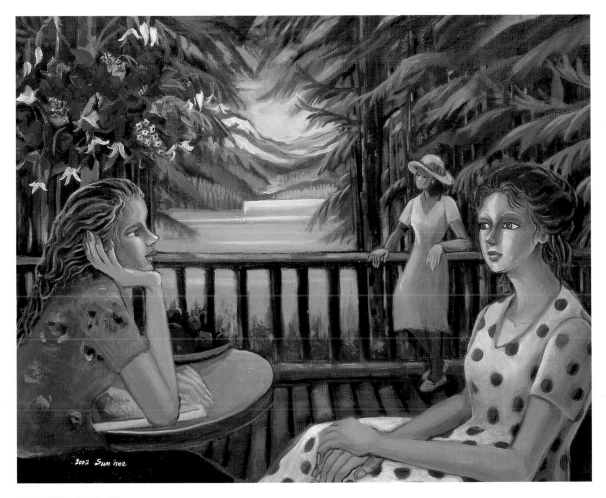

록키 에메랄드 호수의 가족
The Family of the Rocky Emerald Lake
53×45cm, Oil on canvas, 2002

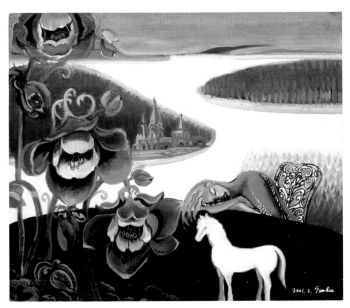

백야나라
The Land of the Midnight Sun
53×45.5cm, Oil on Canvas, 2000

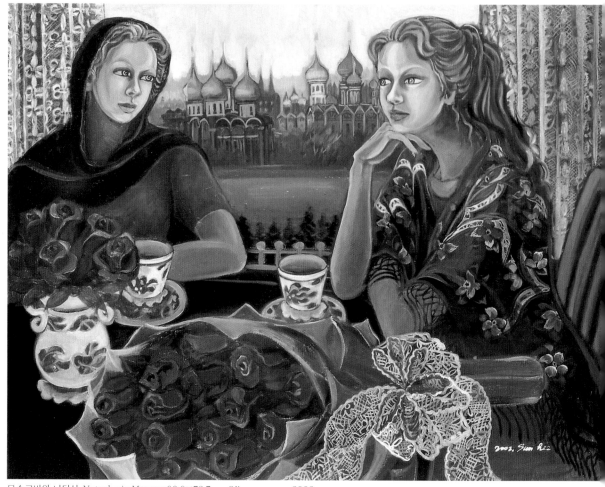

모스크바의 나타샤 *Natasha in Moscow* 90.9×72.7cm, Oil on canvas, 2002

에메랄드 호수 돗지의 하룻밤
The Night of the Emerald Lake
53×45.5cm, Oil on Canvas, 2007

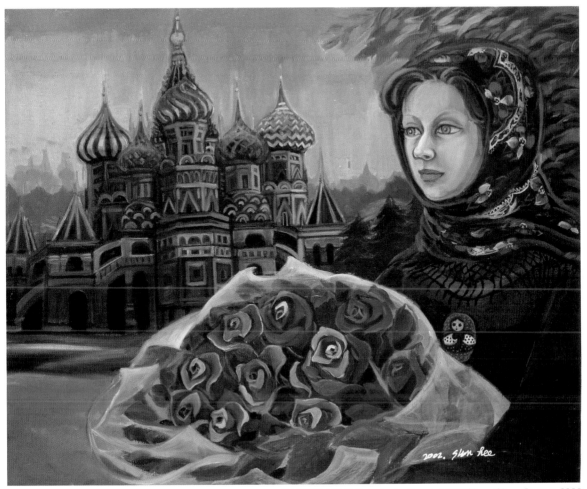

모스크바의 나타샤 *Natasha in Moscow* 72.7×60cm, Oil on Canvas, 2000

나가노 별장
Nagano Castle
72.7×60cm, Oil on Canvas, 2001

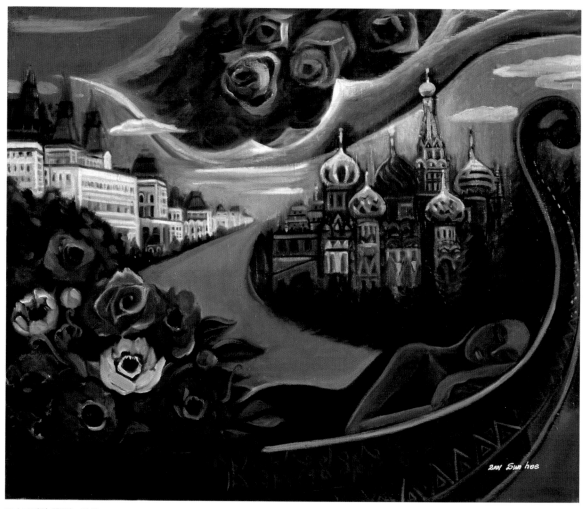

모스크바의 꿈꾸는 집시
Dreams of Moseukeuba in Moscow
Oil on Canvas, 72.7×60.6cm, 2001

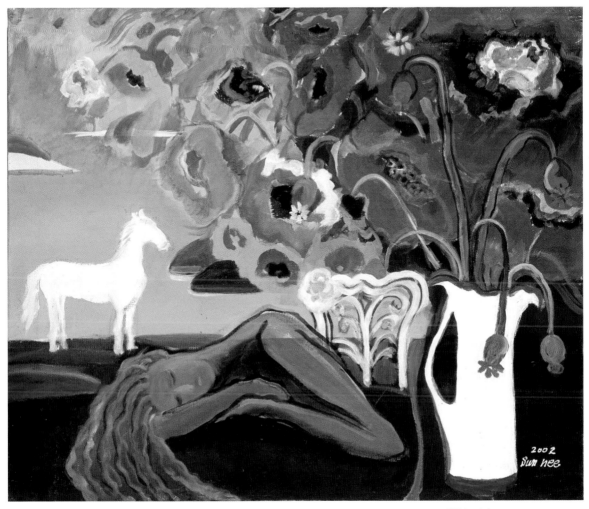

꿈꾸는 집시
Dream Gypsy
53×45cm, Oil on Canvas, 2002

작가 노트

백야의 집시

나는 유년시절부터 환상 속에서 자유로운 영혼을 갈망하며 늘 꿈꾸며 그리기를 좋아했다. 또 성년이 되어서는 정처 없이 유랑하는 집시처럼 꿈꾸는 집시 여행을 좋아했다. 언젠가 첫 해외 스케치 여행으로 나의 어머니와 둘이서 러시아의 생페테르부르크역에서 만난 순수한 집시가족들을 보며 동질감을 느꼈다.

백야의 나라 러시아 대평원을 북쪽으로 달려 핀란드 헬싱키로 향한 기차 시벨리우스호를 타고 가며 수많은 자작나무 숲과 호수를 지나 스칸디나비아 산맥을 넘어 노르웨이 피요르드를 체험하며 줄곧 보랏빛 환상 속에서 동화나라 덴

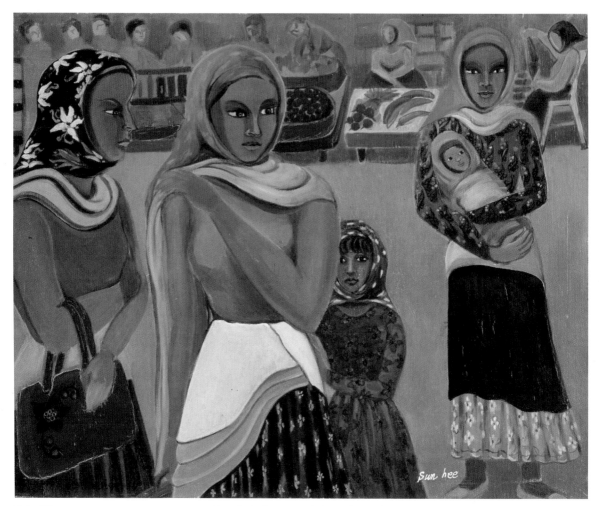

집시 가족
Gypsy Family
90.9×72.7cm, Oil on Canvas, 1998

마크의 인어공주 동상을 만나기까지의 백야의 긴 여행에서 나는 집시 사랑에 빠졌었다.

그 이후 여행은 항상 열정의 집시가 되어 떠나곤 했다. 한곳에 머물지 않고 연어처럼 머문 자리로 되돌아오는 집시되어.

현대미술을 시작할 땐 최첨단의 전위미술, 입체조형미술, 최초의 해프닝까지 주저 없이 실험미술을 강행해온 탓에 자유로운 영혼으로 세계의 미술관 박물관의 작품들과 문화유산 자연유산들을 보고 싶고 직접 체험해보며 느끼고 싶고 이미지화 시키고 싶어서 많이도 다녀보며 이미지화 시켜보았다. 그 여정들이 지금도 이어지며 이 표지화 〈남태평야의 로맨틱 듀오〉 작품도 그 맥락의 불꽃같은 나의 열정의 사랑스러운 표현이다.

남태평양의 로맨틱집시

작업실에서의 일상 탈출하여 염원하던 팔레트와 화구를 챙겨들고 좋아하는 보석빛 보라색 산호와 하루에도 30번 이상 변한다는 블루를 찾아 떠난 남태평양의 작은 섬으로의 집시여행이었다.

뜨겁고 눈부신 남국의 태양아래 빛나던 대자연의 산호섬의 산호숲, 색색의 열대어, 밀림의 꽃과 나무, 투명한 원색의 하늘 아래 푸른 바다와 그 속의 어우

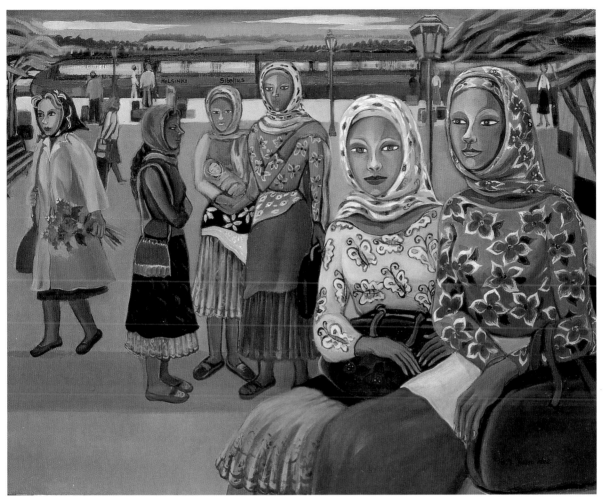

집시 가족
Gypsy Family
90.9×72.7cm, Oil on Canvas, 1998

러진 원주민 섬이나 사랑스러운 허니문 연인들의 달콤한 휴식을 바라보며 그려본 남태평양 로맨틱 듀오중의 한 작품이다. 내가 잘 가던 음악여행에서 사랑스러운 듀오의 연주모습이 떠오르며 한편의 대자연을 배경으로 한 화려하고 웅장한 생생 오케스트라의 협연를 보고 온 것이다.

오늘도 작업실에서 나는 아름다운 싱싱의 세계로 인도하는 꿈의 미치를 타고 현실을 기반으로 하지만 언제나 달콤하고 환상적이며 사랑스럽고 낭만적인 이미지를 표현하고자 또 백야의 집시여행, 도시의 음악여행을 떠날 것이다.

꿈꾸는 집시여인의 세계여행과 집시의 도시음악여행은 앞으로도 쭉 이어질 나만의 환상 속에서 나를 불태울 열정의 주제이다.

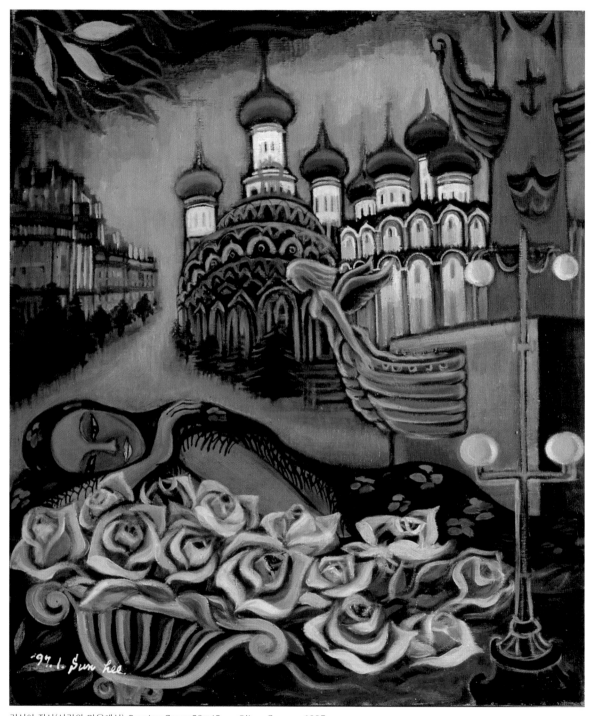

러시아 집시(샤갈의 마을에서) *Russian Gypsy* 53×45cm, Oil on Canvas, 1997

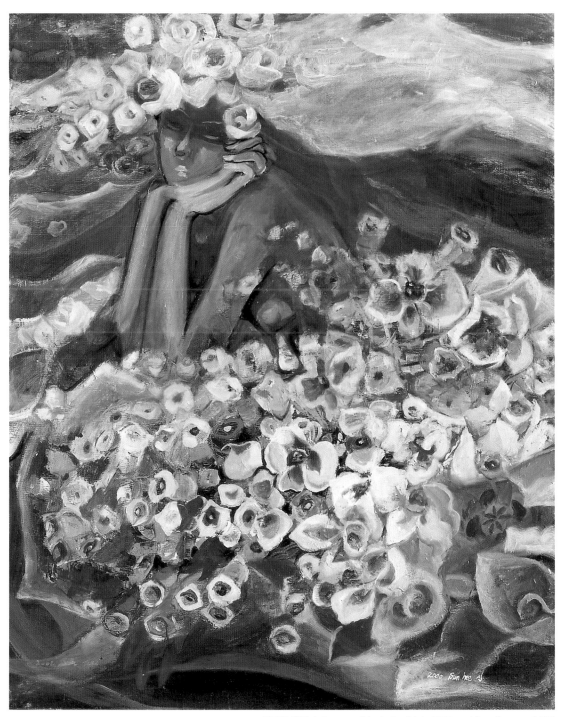

일탈을 꿈꾸다 *Dream of Omission* 90.9×72.7cm, Oil on Canvas, 2000

시크릿 가든 *Secret Garden* 72.7×60.6cm, Oil on Canvas, 1997

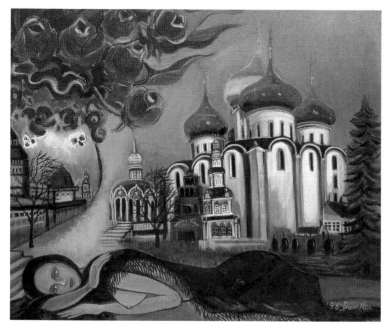

모스크바의 집시 *List of Moscow Gypsy* 45.5×38cm, Oil on canvas, 1996

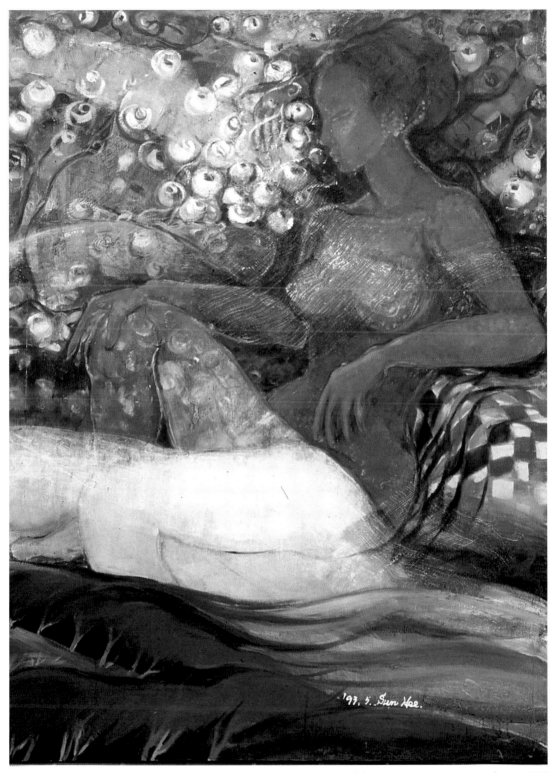

여인 *Woman* 100×80.3cm, Oil on Canvas, 1989

Artist Note

Artist Shim Sun Hee

A gypsy at white night

I have always aspired after free soul in the fantasy and liked to dream and draw since I was little. As I became adult, I've enjoyed wandering around and traveling like a dreaming gypsy. One day, I visited Saint Petersburg in Russia with my mother which was my first sketch travel and I felt homogeneity with the innocent gypsy family where I met there.

Throughout the whole journey on the Sibelius train toward Helsinki Finland crossing north of the vast plain of Russia, I passed lots of birch forests and lakes, climbed over the Scandinavia Mountains, experienced the Norwegian Fjord, and met the statue of Little Mermaid in the purple colored fantastic fairy-tale world in Denmark, and I fell in love with gypsy along this long travel of the white night.

After that, I have always departed like a passionate gypsy. Being a gypsy who returns to where she stayed before, like a

집시뮤직
Gypsy Music
72.7×60.6cm, Oil on Canvas, 2007

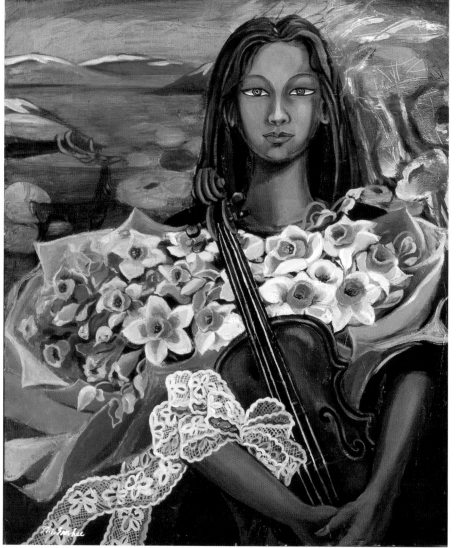

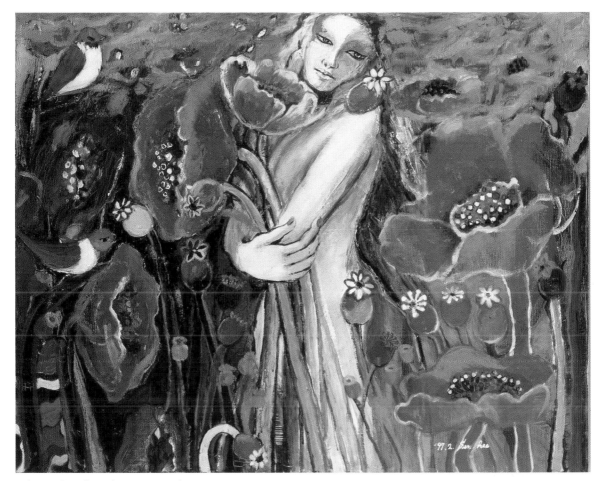

집시의 꿈
Gypsy Dream
91×72.8cm, Oil on Canvas, 1997

salmon that doesn't stay at a place.

When I first started modern art, I pushed ahead experimental arts such as cutting edge avant-garde art, three dimensional modeling, and the first happening performance without hesitation. Thus, I wanted to see and experience the artworks at galleries and museums as well as cultural and natural heritages in the world by myself with my liberal soul, and then I wanted to visualize my feelings. Thus, I have traveled so many places and put those experiences into images. Those journeys allowed me to have the cover painting <The Romantic Duo in the South Pacific> in the same context which expresses my flame-like lovely passion.

The Romantic Gypsy in the South Pacific

I escaped from my studio and daily life as I carried a palette and some picture materials for my long-cherished desire. It was a gypsy traveling to a small island in the South Pacific looking after my favorite purple stone colored coral and the blue which is known to change its colors more than 30 times a day.

This is one of the artworks I painted about the romantic duos in

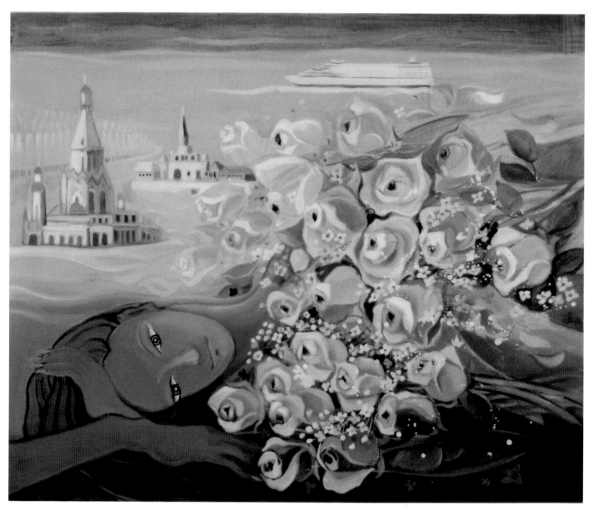

러시아 여정
Russian Journey
90.9×72.7cm, Oil on Canvas, 1996

the South Pacific as I saw the coral forest in the coral island, diverse colors of tropical fish, flowers and trees in the jungle, blue ocean under the transparent original blue sky and the islands of natives living in the sparkling Mother Nature under the hot and shiny sun of the South, and the sweet rest enjoyed by lovely honeymoon couples. I recalled the lovely duo's playing instruments who I saw often at music trips. I saw the brilliant and splendid live orchestra performance with the Mother Nature in the background.

Today, I will take a music trip again in the city which is another gypsy trip at white night by the dream coach that leads to the beautiful world of imagination. The world is based on reality but always sweet, fantastic, lovely, and romantic as I try to express the image of it.

The dreaming gypsy woman's world tour and the gypsy's city travel of music are the themes of passion to devote in my own fantasy now and forever.

백야
Midnight Sun
72.7×60.6cm,
Oil on canvas, 1001

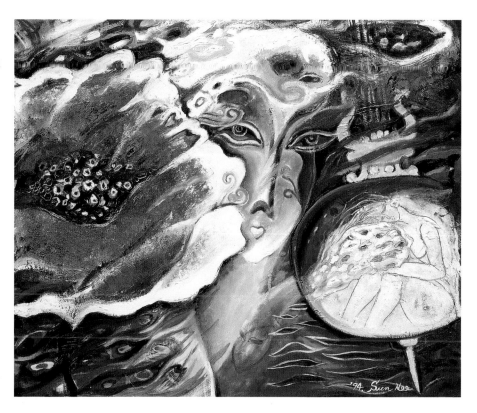

백야
Midnight Sun
72.7×60.6cm
Oil on Canvas, 1995

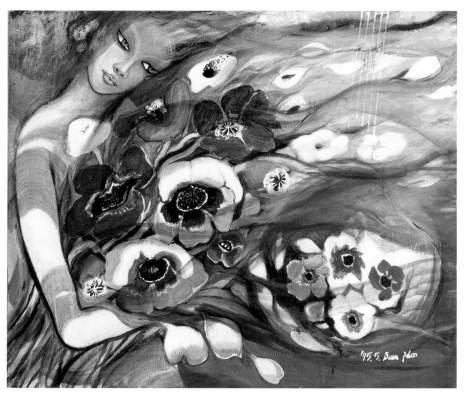

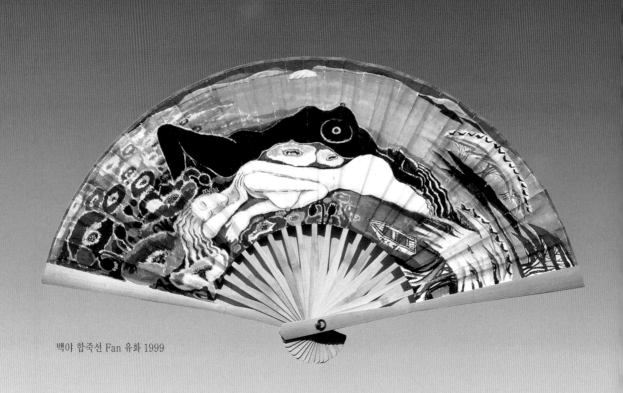

백아 합죽선 Fan 유화 1999

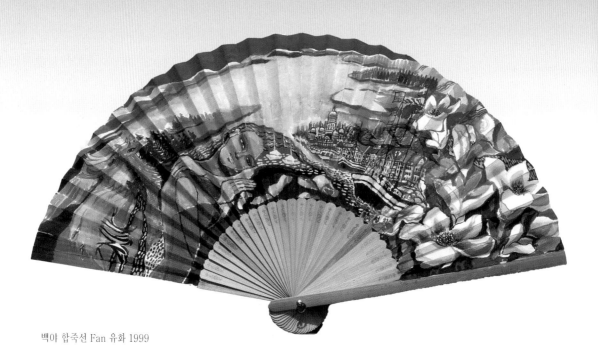

백아 합죽선 Fan 유화 1999

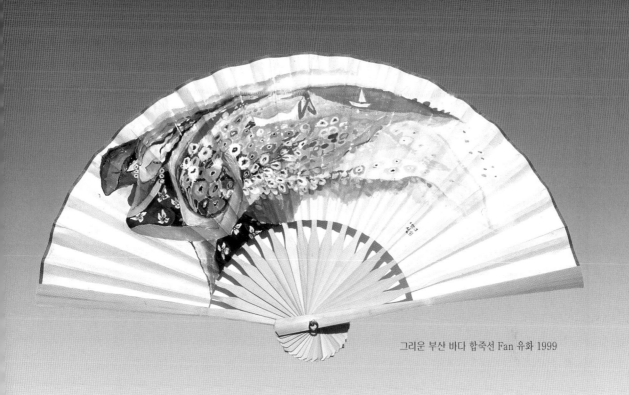

그리운 부산 바다 합죽선 Fan 유화 1999

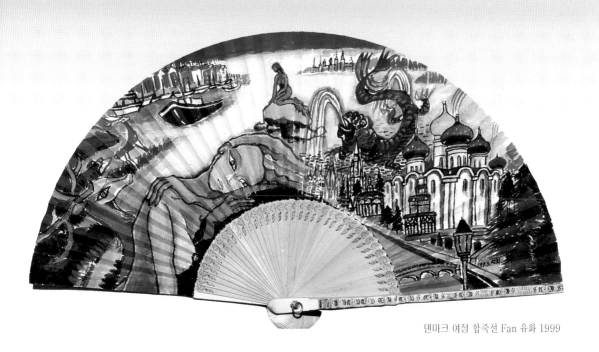

덴마크 여정 합죽선 Fan 유화 1999

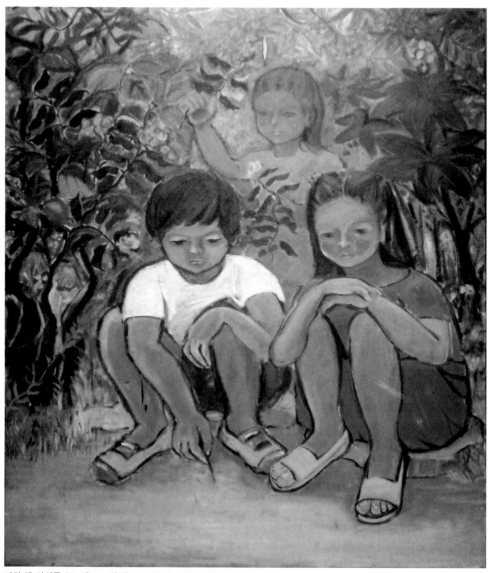

나의 세 아이들 *My Three Chidrens* 130.3×97cm, Oil on Canvas, 1977

음악감상 90.9×72.7cm, *Oil on Canvas*, 1975

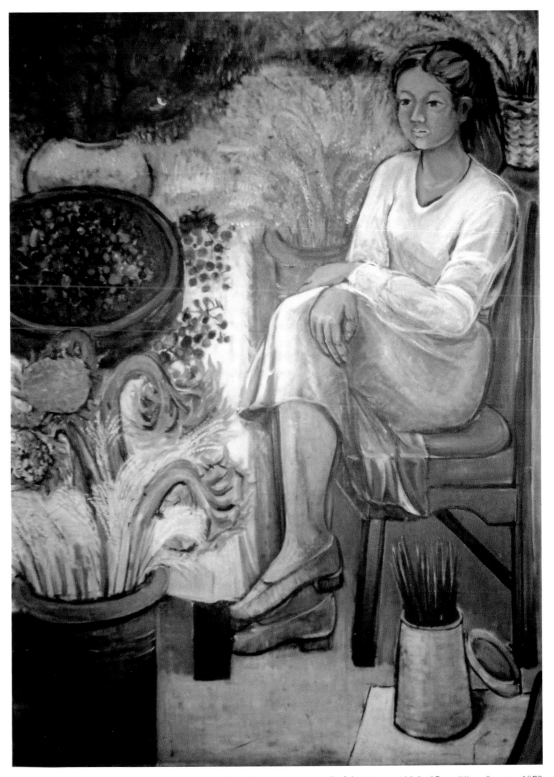

화곡동의 가을 여인 *Hwagok-Dong Fall of the Woman* 130.3×97cm, Oil on Canvas, 1975

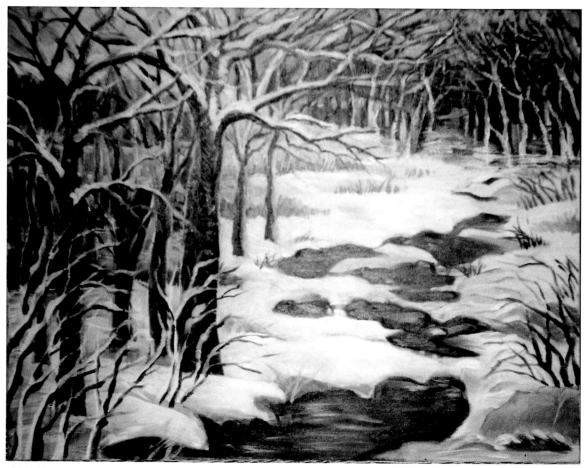

겨울설악(12선녀탕 가는 길) *Winter Mt. Seorak* 53×45.5cm, Oil on Canvas, 1984

1965 회화과 실기실에서
School Pratice Room

목련꽃, 72.7×60.6cm, 1986

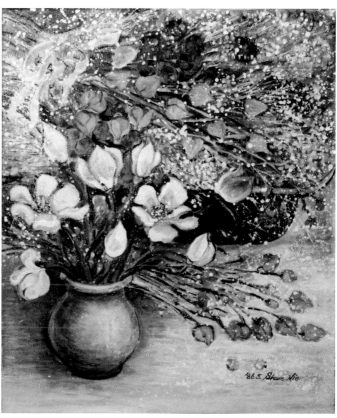

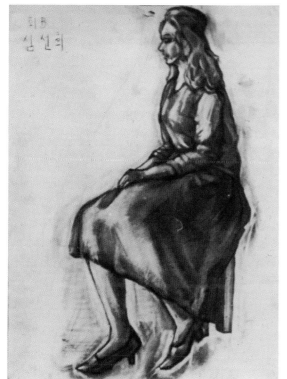

1963 석고뎃상(회화과 실기실)
Gypsum Dessaeng

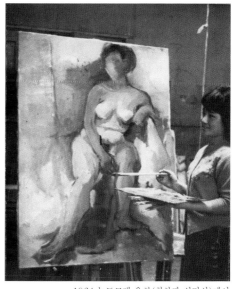

1964 누드모델 유화(회화과 실기실)에서

가을여인 *Autumn Lady* 162.2×130.3cm, 경복궁 국전 입선작, 1965

가을여인 *Autumn Lady* 학교실기실에서 1965

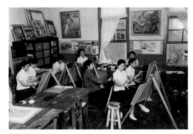

1962년 부산경남여고 미술반 실기실

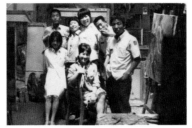

1965년 회화과 실기실, 3,4학년 합반, 박서보 교수님
강의실 권옥림, 조문자, 정강자, 심선희, 박승범

1990년 '67 홍익 와우회전, 동창화가 정강자, 박옥자,
김미대자, 황명혜

1944 부산출생
1963 경남여고 졸업
1967 홍익대학교 미술대학 회화과 졸업
2008 홍익미술대학원 현대미술이론 최고위과정
　　　수료
　　　　　　　수상
홍익미술대학원 홍미연 아트페스티발 올해의 작
가상 수상.

　　　개인전및 초대개인전 12회

2017 선갤러리 제12회개인전
2016 혜원갤러리 제11회 초대개인전
　　　화음콘서트 제10회, 쉐라돈서울팔레스 강
　　　남호텔 그랜드블룸
　　　SCAP 서울컨템폴러리 제9회 개인전 더 팔
　　　레스호텔
2015 코엑스 공예 트랜드페어 갤러리 아트플라자
　　　제8회 초대개인전
　　　갤러리아트플라자 제7회 초대 개인전(첼로
　　　드림)
　　　국립중앙박물관 극장용 화음콘서트 제6회
　　　개인전(뮤직드림)
　　　선 갤러리 제5회 개인전
2010 갤러리 NOU VANCES 제4회 초대개인전
　　　전(까르젤 루브르박물관. 파리)
2009 토포 하우스 제3회 개인전
2008 서울국제 뉴 아트페어 제2회 개인전
　　　리더스 수 갤러리 제1회 개인전

　　　개인전·초대 개인전 및 그룹전

2017 선갤러리 제12회 개인전

2017 홍익미술대학원 최고위과정 홍미연아트 페
　　　스티발(조선일보미술관)
2016 혜원갤러리제11회 초대개인전
　　　화음콘서트제10회 초대개인전 , (쉐라돈서
　　　울팔레스 강남호텔 그랜드블룸)
　　　SCAP 서울컨템폴러리제9회 초대 개인전(
　　　더 팔레스호텔)
　　　홍익루트전 임원 송별특별초대전 갤러리두
　　　서울아트쇼 2016. 코엑스 초대전(갤러리 아
　　　트 플라자)
　　　중국북경 아트차이나 2016. 중국북경문화
　　　예술박람회.초대전
　　　중국 중산 중산엑스포 국제미술아트페어
　　　초대전
　　　홍익여성화가협회홍익루트전 정기전(미술세
　　　계)
　　　SOAF 서울 오픈아트페어 2016. 코엑스 초
　　　대전
　　　혜원갤러리 힐링아트전
　　　혜원갤러리 힐링아트특별전
　　　리서울·갤러리 홍익루트임원(미래의 근원전)
　　　초대전
　　　경남도 서부청사개청기념 화음콘서트 무대
　　　배경 작품영상 출품
　　　홍익미술대학원 최고위과정 홍미연아트 페
　　　스티발(예총회관)
2015 코엑스 공예 트랜드페어 갤러리아트플라자
　　　제8회 초대 개인전(첼로드림)
　　　갤러리 아트플라자 제7회개인전
　　　국립중앙박물관 극장용 화음콘서트제6회
　　　개인전(뮤직드림)
　　　선 갤러리 제5회 개인전

제 2회 홍익대 회화과 동문전(H 갤러리)
해피월코리아2015 홍익대학로 아트센터
홍익루트정기전(미술세계)
홍익미술대학원 최고위과정 홍미연아트 페
스티발(예총회관)
이태리2015밀라노 세계 엑스포기념 한국미
술의오늘전(밀라노)
와우열전(호마미술관)
2014 홍익루트 기금마련전(AP갤러리)
홍익루트 정기전(조선일보 미술관)
그리스아테네(한류미술의 물결전)
한국현대작가 초대전(까르젤 루브르미술
관)
홍익예도전(호서미술관)
홍익미술대학원 최고위과정 홍미연정기전
예총회관
2013 홍익루트정기전(공아트 스페이스)
홍익미술대학원 최고위과정 홍미연정기전
예총회관
홍미연 소리없는 울림전(국회의원회관)
2012 홍익루트 정기전(조선일보 미술관)
소리없는 울림전(국회의원회관)
홍익예도전(호서 미술관)
Salom 2011 SNBA(까르젤 루브르미술관.
파리)
홍미연 송년 초대전(강남위 갤러리)
2011 한국미술협회전(킨텍스)
Salon 2011 SNBA(까르젤루브르미술관)
홍익여성 화가협회 30주년 기념전(예술의
전당)
홍익 63ART전(인사갤러리)
베세또전(베세또 갤러리)

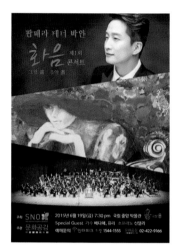

2015년 테너 박완과의 화음음악회 포스터

남편(신재운)과 함께

Comparasons(그랑팔레 루브르박물관, 파리)

2006 한국미술협회전(예술의 전당)
Comparasons(그랑팔레 루브르박물관. 파리)

2005 제8회 Salon de Printemps 프랑스 Vendee

2004 Arts en Capital, Salon Comparaison(그 랑팔레.파리)
한국미술협회전(예술의 전당)
홍익와우회전(나 겔러리)

2003 Salon d'Automme(그랑팔레,파리)
한국미술협회전(예술의 전당)
홍익여성화가(인사아트센타)

2002 홍익여성화가협회정기전(홍익대학교 현대미 술관)

2001 국립현대미술관 초대전 현대미술의 전개전 (국립현대미술관)
한국청년작가연립전(최초의 실험미술 조형 작품출품과최초의 헤프닝 참여)
KBS 디지털 미술관(헤프닝 :우산을 찢은 화가들 방영)
현대미술 다시읽기 초대전(한원미술관)
홍익여성화가 협회전(서울시립미술관)

2000 홍익67와우회전(백악미술관)

1999 한국선면전 (백악예원)

1999 한국선면전 (춘천종합예술화관)
와우전 (예나르 겔러리)

1996 한국 선면전(백악예원)

1995 한국선면전 (경인미술관)

1986 홍익67와우회전(관훈미술관)

홍익여성화가 협회전(문예회관)

1971 재부산 홍익와우회전(부산상공회의소)

1970 재부산 홍익와우회전(부산상공회의소)

1969 재부산 홍익와우회전(부산상공회의소)

1968 현대작가 종합미술대전(덕수궁 중앙공보 관)

1967 한국청년작가 연립전 (중앙공보관 .
최초의 실험미술 헤프닝참여(오광수극본)

1966 신인예술상 장려상

1965 대한민국 국전 제14회 입선 (경복궁미술관)

1962 홍익대학교 전국 고등학생 실기대회 특선

현재 한국미술협회 회원
홍익여성화가협회 감사
홍미연 자문위원

저서(2017 심선희 화집:소담출판사)

수록책

2001 한국현대미술의 전개 (국립현대미술관)
한국의 행위미술 (국립현대미술관)
한국 현대미술 다시읽기(도서출판:ICAS)

2012 여성중앙 부록표지화

2013.3 월간 멋진인생

2014.2 월간 RICH

2014. 5 월간시사뉴스타임

2014. 7 골프헤럴드 GOlf Herald

2014. 11 월간에세이

2017. 구름모자 가게 (전하라 시집표지)

2010 갤러리 NOU VANCES 제4회초대개인전
전(까르젤 루브르박물관과,파리)
한국미술협회전(예술의 전당)
Salon 2010 SNBA(까르젤 루브르박물관.
파리)
홍미연 장애아동돕기 자선전(국회의원회 관)
서울국제뉴아트페어(시나프)서울미술관
청송 국립미술관 초대전(청송국립미술관)

2009 토포 하우스 제3회개인전
홍익예도 42년 화연전(이형갤러리)
한국미술협회전 (예술의 전당)
Salon2009 SNBA(루브르박물관. 파리)
홍익여성작가협회전(갤러리 정)

2008 서울국제 뉴 아트페어제2회 개인전
리더스 수 갤러리제1회 개인전
한국미술협회전(예술의 전당)
홍미연, 현대미술최고위과정 수료작품전
(홍대현대미술관)
홍익여성화가협회전(갤러리 정)
한국미술협회전(예술의 전당)
홍미연, 현대미술최고위과정 수료작품전
(홍대현대미술관)
홍익여성화가협회전(갤러리 정)

2007 홍익여성화가협회전(갤러리정)
Salon 도돈드(그랑팔레. 파리)

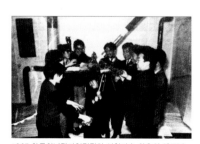

1967 한국청년작가연립전의 실험미술 최초의 헤프닝
오광수극본

이메일 sunhshim@hanmail.net

1962년 부산경남여고 교내 야외 사생

1967 한국청년작가연립전

2001 과천국립현대미술관, 미니 작품. 정강자

1944 Born in Busan
1963 Graduated from Gyeongnam Girls' High School
1967 Graduated from Hongik University Department of Fine Arts
2008 Degree of Modern Arts Theory Advanced Program of Hongik University Graduate School of Art

Awards

Artist of the Year by Hongik University Graduate School of Art Hongik Artists Association Art Festival

12 times of solo exhibitions and invited solo exhibitions

1944 Born in Busan
1967 Graduated from Hongik University Department of Fine Arts
2008 Advanced Degree Program of Modern Arts Theory at Hongik University Graduate School of Art
Awarded with 'Artist of the Year' by Hongik University Graduate School of Art Hongik Artists Association Art Festival

2017 The 12th solo exhibition at Sun Gallery
2016 The 11th invited solo exhibition at Hyewon Gallery
The 10th Hwaeum (Art and Music) Concert at Sheraton Seoul Palace Gangnam (Grand ball room)
SCAP Seoul Contemporary, the 9th solo exhibition at Palace Hotel
2015 COEX Handicraft Trend Fair, the 8th solo exhibition at Gallery Art Plaza
The 7th solo exhibition at Gallery Art Plaza (Cello Dream)
Hwaeum (Art and Music) Concert at National Museum of Korea, the 6th solo exhibition (Music Dream)

The 5th solo exhibition at Sun Gallery
2010 Gallery Nou Vances the 4th solo exhibition (Carrousel Louvre Museum, Paris)
2009 The 3rd solo exhibition at Topo House
2008 The 2nd solo exhibition at Seoul International New Art Fair
the 1st solo exhibition at Leader's Su Gallery

Solo Exhibition, invited solo exhibition and group exhibition

2017 The 12th solo exhibition at Sun Gallery
2017 Hongik Graduate School of Art Advanced Degree Program Hongik Artists Association Art Festival (Chosun Gallery)
2016 The 11th solo exhibition at Hyewon Gallery
Hwaeum (Art and Music) Concert, the 10th solo exhibition (Sheraton Seoul Palace Gangnam Grand Ball Room)
SCAP Seoul Contemporary, the 9th invited solo exhibition (The Palace Hotel)
Hongik Route Exhibition for Farewell Executives at Gallery Doo
Seoul Art Show 2016, Coex invited exhibition (Gallery Art Plaza)
Art China 2016 in Beijing, China, invited exhibition at Beijing China Culture Art Fair
Invited exhibition at International Art Fair at Zhongshan Expo in Zhongshan, China
Hongik Female Artists' Association's Hongik Route Exhibition (Arts World)
Seoul Open Art Fair 2016, invited exhibition at COEX
Healing Art Exhibition at Hyewon Gallery
Hongik Route Executive's Exhibition at Lcc Scoul Gallery (Origin of the Future)
Hongik Graduate School of Art

Advanced Degree Program Hongik Artists Association Art Festival (Yechong Center)

2015 COEX Handicraft Trend Fair Gallery Art Plaza, the 8th solo exhibition (Cello Dream)
Gallery Art Plaza, the 7th solo exhibition
National Museum of Korea Hwaeum Concert, the 6th solo exhibition (Music Dream)
Sun Gallery, the 5th solo exhibition
the 2nd Hongik University Fine Arts Alumni's Exhibition (H Gallery)
Happy Wall Korea 2015, Daehakro Hongik Art Center
Hongik Route Exhibition (Arts World)
Hongik Graduate School of Art Advanced Degree Program Hongik Artists Association Art Festival (Yechong Center)
2015 Milan Italy World Expo, Korean Arts Today (in Milan)
Wawoo Exhibition (Homa Gallery)
2014 Hongik Route Fundraising Exhibition (AP Gallery)
Hongik Route Exhibition (Chosun Gallery)
Athens Greece (Korean Arts Wave Exhibition)
Invited exhibition of Korean Modern Artists (Carrousel Louvre Museum)
Hongik Yedo Exhibition (Hoseo Gallery)
2013 Hongik Route Exhibition (Gong Art Space)
Hongik Graduate School of Art Advanced Degree Program Hongik Artists Association Art Festival (Yechong Center)
Hongik Artists Association Silent Resonance Exhibition (Assembly Hall Center)
2012 Hongik Route Exhibition (Chosun Gallery)

(오른쪽) 이명화 양승임 후미꼬 지박작곡가 테너 박완 심선희

정강자, 하종현 교수, 문혜자

홍미연 2014 올해의 작가상 시상식 한홍섭회장님, 박 명선, 강형구, 심선희, 김무일

Silent Resonance Exhibition (Assembly Hall Center)

Hongik Yedo Exhibition (Hoseo Gallery)

Salon 2011 SNBA (Carrousel Louvre Gallery, Paris)

Hongik Artists Association Year End Exhibition (Gangnam We Gallery)

2011 Korean Arts Association Exhibition (KINTEX)

Salon 2011 SNBA (Carrousel Louvre Gallery)

Hongik Female Artist Association 30th Anniversary Exhibition (Seoul Art Center)

Hongik 63 Art Exhibition (Insa Gallery)

BESETO Exhibition (BESETO Gallery)

2010 Gallery Nou Vances, the 4th invited exhibition (Carrousel Louvre Gallery, Paris)

Korea Arts Association (Seoul Art Center)

Salon 2010 SNBA (Carrousel Louvre Gallery, Paris)

Hongik Artists Association Charity Exhibition for Handicapped Children (Assembly Hall Center)

Seoul International New Art Fair (SINAF) Seoul Hall

Invited exhibition at Cheongsong International Museum

2009 Topo House, the 3rd solo exhibition

Hongik Yedo 42 Years, Hwayeon Exhibition (Yihyeong Gallery)

Korean Arts Association Exhibition (Seoul Arts Center)

Salon 2009 SNBA (Louvre Museum, Paris)

Hongik Female Artists' Association Exhibition (Gallery Jeong)

2008 Seoul International New Art Fair, the 2nd solo exhibition

Leader's Su Gallery, the 1st solo exhibition

Korean Arts Association Exhibition (Seoul Art Center)

Hongik Artists Association, Degree Completion Exhibition of Advanced Degree Program of Modern Arts (Hongik Modern Gallery)

Hongik Female Artists Association (Gallery Jeong)

2007 Hongik Female Artists Association (Gallery Jeong)

Comparasons (Grand Palais Louvre Museum, Paris)

Salon Dodonde (Grand Palais, Paris)

2006 Korean Arts Association Exhibition (Seoul Arts Center)

Comparasons (Grand Palais Louvre Museum, Paris)

2005 the 8th Salon de Printemps France, Vendee

2004 Arts en Capital, Salon Comparisons (Grand Palais, Paris)

Korean Arts Association (Seoul Arts Center)

Hongik Wawoo Exhibition (Na, Gallery)

2003 Salon d'Automme (Grand Palais, Paris)

Korean Arts Association Exhibition (Seoul Arts Center)

Hongik Female Artists (Insa Art Center)

2002 Hongik Female Artists Association Exhibition (Hongik University Modern Gallery)

2001 National Museum of Modern Arts, invited exhibition for the 'Process of Modern Arts'

Korean Young Artists' Coalition Exhibition (Happening: The Artists who tore down umbrellas)

Invited exhibition of 'Read Again the Modern Arts' (Hanwon Gallery)

Hongik Female Artists Association Exhibition (Seoul Museum of Art)

2000 Hongik 67 Wawoo Exhibition (Baekak Gallery)

1999 Korea Line and Area Exhibition (Baekak Art Center)

1999 Korea Line and Area Exhibition (Chuncheon Total Arts Center)

Wawoo Exhibition (Yenareu Gallery)

1996 Korea Line and Area Exhibition (Baekak Art Center)

1995 Korea Line and Area Exhibition (Gyeongin Gallery)

1986 Hongik 67 Wawoo Exhibition (Kwanhun Gallery)

Hongik Female Artists Association Exhibition (Munye Center)

1971 Hongik Wawoo Exhibition in Busan (Busan Commerce Center)

1970 Hongik Wawoo Exhibition in Busan (Busan Commerce Center)

1969 Hongik Wawoo Exhibition in Busan (Busan Commerce Center)

1968 Modern Artists Total Arts Exhibition (Central Promotion Hall at Deoksugung Palace)

1967 Korean Young Artists Coalition Exhibition (Central Promotion Hall)

Participated in the first experimental art happening (written by Oh Gwang Su)

1966 Granted the Participation Prize of New Artists Award

1965 Selected by the 14th Korea National Arts Awards (Gyeongbokgung Palace Gallery)

1962 Hongik University National High School Students' Painting Competition, Special Prize

Present: Member of Korean Arts Association

Audit of Hongik Female Artists Association

Advisor of Hongik Artists Association

Publications (2017 Art Book of Shim Sun Hee: Sodam Publication)

Also contained in the following publications

2001 The Process of Korean Modern Arts (National Museum of Modern Arts)

Performance Arts in Korea (National Museum of Modern Arts)

Read Again Korean Modern Arts (Publisher: ICAS)

2012 Cover of the bonus book of Women's Joongang

Mar. 2013 Monthly Great Life

Feb. 2014 Monthly Rich

May 2014 Sisa News Time (monthly magazine)

July 2014 Golf Herald

Nov. 2014 Monthly Essay

2017 Cloud Hat Shop (Cover of poem by Jeon Ha Ra)

e-mail: sunhshim@hanmail.net